COUNTRY HOUSES OF THE MARCHES

JOHN KINROSS

AMBERLEY

Front cover: Weston Park. (Courtesy of Gareth Williams)

Back cover: Brockhampton Manor Hall. (Courtesy of Steve and Rosemary Wolstencroft)

This edition first published 2022

Amberley Publishing
The Hill, Stroud
Gloucestershire GL5 4EP

www.amberley-books.com

British Library Cataloguing in Publication Data.
A catalogue record for this book is available from the British Library.

ISBN 978 1 3981 0107 4 (print)
ISBN 978 1 3981 0108 1 (ebook)

Typesetting by SJmagic DESIGN SERVICES, India.
Printed in Great Britain.

CONTENTS

DEFINITION

The borderland between England and Wales has long been a region of contention. Its distinctive geography, wedged roughly between Welsh mountains and English riverbeds, has not only isolated this rural, sparsely populated slice of land, but created a unique identity.

Stretching along the bordering counties with English Cheshire, Shropshire and Herefordshire, the Welsh Marches are made up of a mixture of mountains and moorlands, farms and wooded river valleys. The natural history of the region is like most parts of the British Isles – inextricably linked to the activities of man across many thousands of years.

Andrew Alliott
'Marches', *New Naturalist*, 118 (2011)

INTRODUCTION

This is the third and final book in the 'Marches' series and readers may ask 'Why are some houses missing?' If you have *Castles of the Marches* (2015) you will find these castles open to the public:

Cheshire: Dunham Massey (NT)
Shropshire: Stokesay (NT)
Hereford: Treago

Two are inhabited castles – Dunham Massey is built on the site of a castle – and Treago is a privately owned castle. Stokesay Castle is uninhabited.

There are a number of houses, both in Wales and over the border, that are only open to large parties. I have mentioned them in an appendix. Why wasn't Raglan Castle in the *Castles* book, you may ask? It is called a 'Palace' in the guidebook. I agree, it is a very superior ruin and the inhabitants lived in luxury right up to the Civil War, when it was slighted, but not too badly, so that visitors today can see the luxurious kitchens, hall and private chambers.

I apologise if some houses are missing. We have only ninety-six pages and the illustrations cannot be allowed to become too small, or the price too large.

The National Trust have, in 2022, closed their shops in Berrington, Croft, Dudmaston, Sunnycroft and Benthall. However, those at Chirk, Erddig and Attingham remain open.

ABBREVIATIONS
CADW: Welsh Historic Monuments (the word means 'Preserve' in Welsh)
EH: English Heritage
NT: National Trust
HH: Historic Houses

HEREFORDSHIRE

BERRINGTON HALL
Off Hundred Lane, Berrington, HR6 0DW
(www.nationaltrust.org.uk/berrington-hall)

Divided by the A49 close to Leominster, Berrington Hall was built by Henry Holland, architect of Brooks's Club in St James's, London. The land was purchased by Thomas Harley, 3rd son of the Earl of Oxford, in 1775 from the Cornewall family. Thomas had been Lord Mayor of London and MP for Hereford. Holland's father-in-law was Capability Brown, who designed the park, which has some very aged trees and a lake.

John Cornforth in *Country Life* (9.1.92) writes: 'The most obvious French elements in the (drawing) room are the garlands around the circular grisailles over the door and pier glasses between the windows … On the window wall the garlands form complete frames to the painted roundels and then cross over to frame the upper parts of the pier glasses, whose rod and leaf detail is not specifically French, to create a continued effect that is intended to be French.' He admits Holland only went to France in 1785, two years after Berrington was built that 'the treatment of the centre window on the north side of the house, which may seem to us French inspired, is not accepted by French architectural historians.'

The entrance, facing south-west, has a wide portico and steps with four ionic pillars. Harley's daughter, Anne, married George, 2nd son of Lord Rodney, the admiral. The dining room has some sea pictures featuring Rodney's successful battles. The staircase is outstanding and the drawing room has a ceiling attributed to Biaggio Rebecca, who worked at Attingham (see page 29). In 1901 the house was sold to a Lancashire cotton merchant, Lord Cawley, who made a fortune selling black dye after the death of Queen Victoria's Prince Albert. One of the new additions (2019) is a remarkable eighteenth-century dress, repaired from nearly a dozen parts, on view by the stairs.

In 1966 Donald Insall & Partners removed a Victorian tower, and the large courtyard at the rear was altered so that the servants' room could be made into the tearoom and the estate office into the shop (NB: the shop and that at Croft have now closed). In Eye church, a mile or so from Berrington, is the tomb of Thomas Harley (1804) by Lewis of Cheltenham and also a Blomfield monument to the three sons of Lord Cawley killed in the First World War. (If you visit this church, a torch is needed as we were unable to find the light switches.)

Lady Cawley lived until she was 100, dying in 1978. Her sitting room is open to the public and there are also back stairs tours where you can follow what

happened to William Kemp, the butler. For those who are not good at walking, Berrington has a couple of tractor-trains.

The grounds and walled garden are well worth a visit. For bird watchers, Berrington was the place where there was a golden eagle caught in a trap that was eventually stuffed and no doubt put in a glass case somewhere. H. L. V. Fletcher

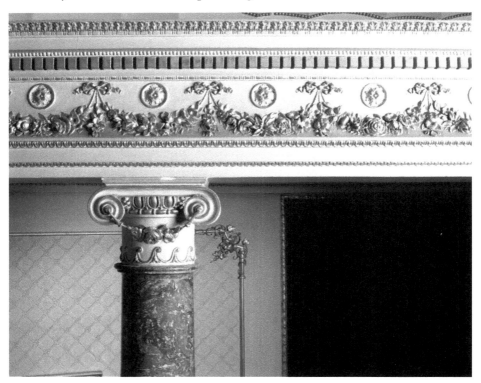

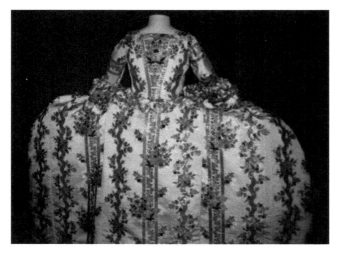

Above: Eighteenth-century decoration in the boudoir. (Country Life Picture Library)

Left: Eighteenth-century dress. (J. S. N. Kinross)

in *Herefordshire* (1948) also mentions that Berrington had a heronry, but I don't think it survives. We once saw a heron flying over our church on Christmas Day, so they are not uncommon in the county.

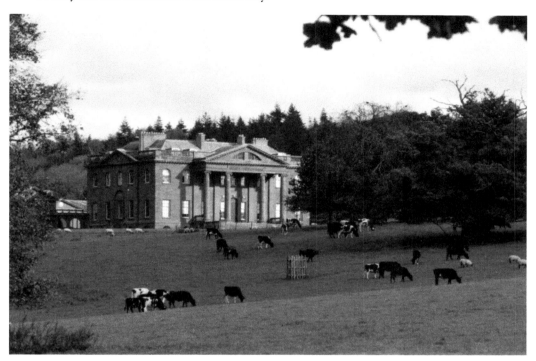

Above:
Berrington Hall.
(National Trust)

Right: Berrington
Hall. (J. S. N.
Kinross)

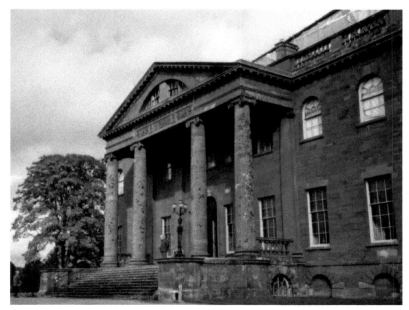

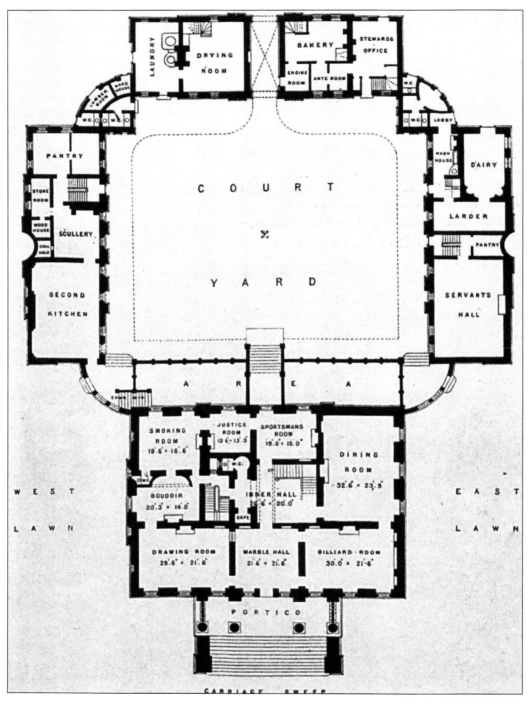

Berrington Hall, Herefordshire. (Country Life Picture Library)

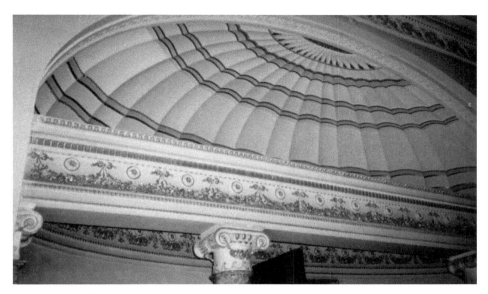

The boudoir ceiling. (J. S. N. Kinross)

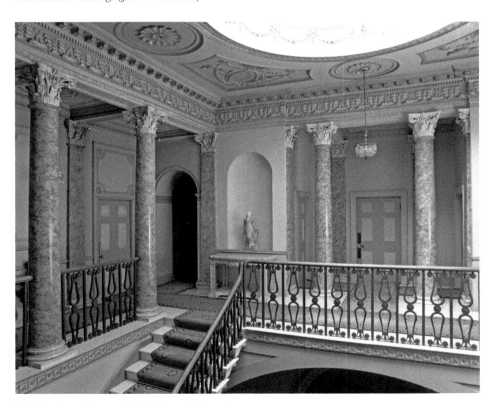

The landing. (Country Life Picture Library)

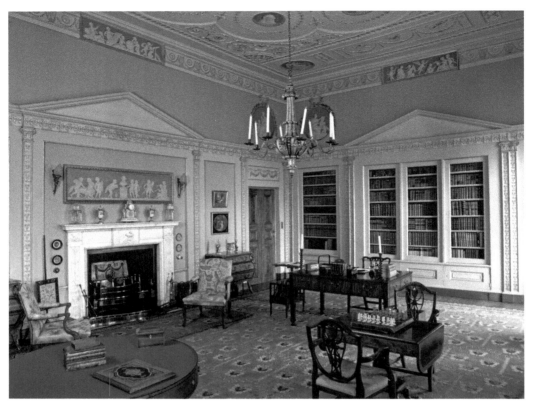

Berrington library. (Country Life Picture Library)

BROCKHAMPTON MANOR HOUSE & GATEHOUSE
Bringsty, Bromyard, WR6 5TB
(www.nationaltrust.org.uk/brockhampton)

John Demulton built himself a fifteenth-century farmhouse in traditional Hereford black and white style. The three chimneys are of brick, dating from *c*. 1700. The hall has a central truss and the parlour was added later. In 1871, Buckler added a gallery over the screens passage. Two other architects contributed to repairs for the National Trust in 1952 and 2000. Below the house are the ruins of a small chapel.

The gatehouse looks top heavy. It dates, according to tree rings, to 1542/3 and must have been dangerous for the gatekeeper upstairs in a high wind. The whole building does not look safe.

There is a tearoom nearby in the Old Apple Store, and in 1798 a new chapel was built by prison architect George Hyfield for Colonel Barneby, who lived in the big house nearby. It has some fine Eginton glass (*c*. 1810) and all the seating is arranged as a university chapel. It is said the choir consisted of the colonel's female staff, whether or not they could sing.

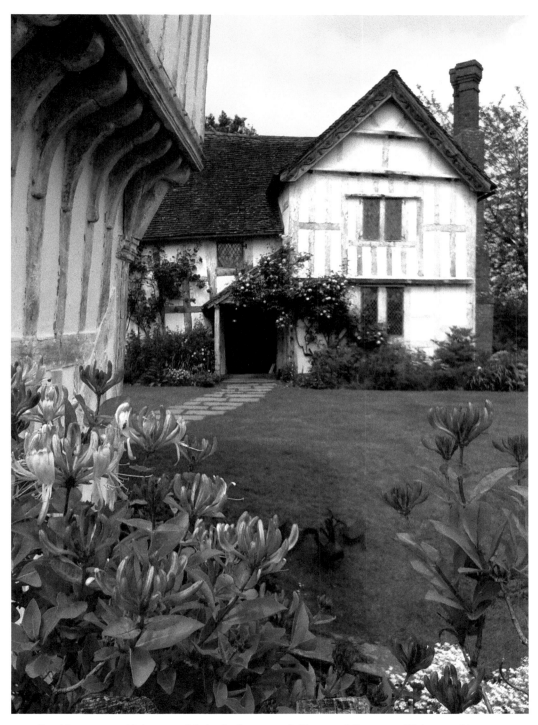

Brockhampton, with honeysuckle in the foreground. (Steve and Rosemary Wolstencroft)

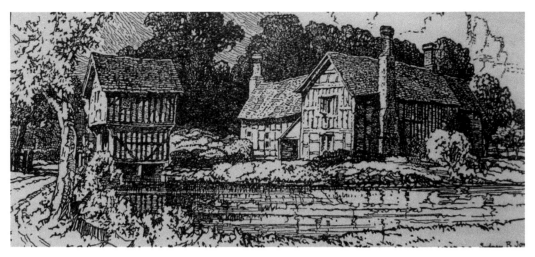

Brockhampton Manor House. (Sydney R. Jones)

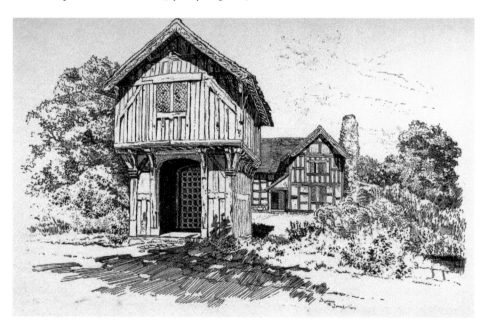

Brockhampton Manor House. (Sydney R. Jones)

BURTON COURT (HH)
Eardisland, Nr Leominster, HR6 9DN
Mr and Mrs Simpson
(www.burtoncourt.com)

Originally a medieval house, Burton Court was altered by Clough Williams-Ellis
of Portmeirion fame for the then owner, Colonel Legh Clowes, in 1911–12. The

round-arched entrance, which Pevsner calls 'Free Tudor', was probably part of Kempson's design. The cantilever stair, wrought-iron ballustrated, and skylight are also Kempson – they lead into the original medieval hall, with an elaborate timber roof, much of which is fifteenth century. Most of the front rooms date from 1865.

The owners have varied displays of costumes, natural history and model ships.

CROFT CASTLE
Yarpole, Leominster, HR6 9PW
(www.nationaltrust.org/croft-castle)

This is not really a castle, but a seventeenth-century home with corner turrets. There was a castle nearby owned by Bernard de Croft at the time of the Domesday Book, which was west of the present building. From the outside it looks square with a central courtyard, but the north side is angled in which is not easily noticed until you see a plan.

The most famous medieval Croft, Sir Richard, fought for King Edward IV at Mortimers Cross and Tewkesbury. He survived the accession of King Henry VII and is buried next to his wife Eleanor with a stately monument in the church opposite the entrance.

Sir James Croft, his grandson, was Comptroller of the Household to Queen Elizabeth I. The Crofts suffered in the Civil War, one being killed after a skirmish at Stokesay, whilst attempting to get into his own land. It was left to Herbert, Bishop of Hereford, to build the present house. In the eighteenth century, Sir Archer Croft, in spite of being Governor of New York (which he never visited), was one of the speculators who, having lost a lot of money with the South Sea Bubble, sold Croft to his neighbour Richard Knight of Downton.

It became the home of his daughter and her Welsh husband Thomas Johnes. They employed Thomas Pritchard, who was influenced by Shobdon's Rococo Gothic style, and inside, the library, drawing room, blue room and oak room are all Pritchard. In 1913, Walter Sarel, another architect, put a Venetian courtyard window in the dining room and made other improvements. Thomas Johnes preferred to live in Wales and his huge house, Hafod, caught fire in 1807, so Croft was sold again to Somerset Davies, a wealthy Leominster mercer. In the First World War, Herbert Kevill-Davies was killed, as was Sir Herbert Croft's son – also Herbert – at Gallipoli.

In 1923, the Crofts, then living at Lugwardine Court, made an offer of £30,000 for their old home, which was accepted. In the Second World War, Sir James Croft, having survived the brief Norway campaign, was killed accidently in Scotland while training, and the house passed to Sir Henry Page Croft, first Lord Croft, a Tory in the House of Lords. During the war a convent school moved in and Diana, Lord Croft's sister, was partly responsible for getting the house taken over by the National Trust in 1957.

Writing in December 1987, John Cornforth ends his article: 'To those who have known the house over the past 30 years, the sense of steady growth and improvement must be enormously encouraging.'

The family still have a flat overlooking the garden, but Lord Bernard Croft died in 2018 and it is unsure of the family's position with Croft today.

Apart from the busy gardens, there is an avenue of old chestnut trees. One was measured 36 feet around the bole in the 1940s. The Iron Age camp of Croft Ambrey, supposed to have been occupied by Caractacus, looks over the Roman road, Watling Street, that runs from Mortimers Cross to Wigmore and beyond. So Croft is a favourite spot for walkers, has a good café, garden looked after by volunteers, and a second-hand bookshop. There is just time for those who are only in the area for one day to see both Croft and Berrington in one day, but if in that order it is advisable to send someone ahead as the tea shop at Berrington tends to run out of supplies early on and you need to be there by 3.00 p.m.

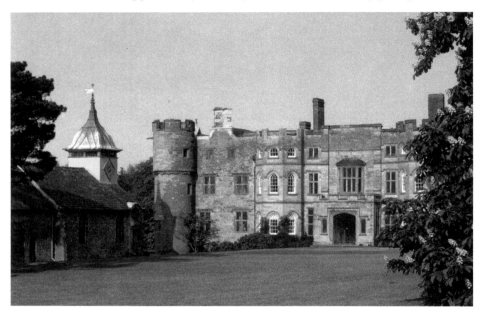

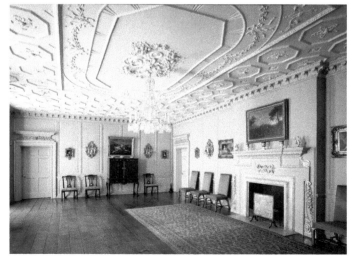

Above: Croft Castle and church. (National Trust)

Left: The saloon. (Country Life Picture Library)

Eastnor Castle (HH)
Ledbury, HR8 1RL
(www.eastnorcastle.com)

This house was built on the parkland of Eastnor that also occupies scanty remains of Bronsil Castle, home of the Beauchamps. This had eight towers and the last one collapsed in 1991 (see *Castles of the Marches*). However, it was Earl Somers, whose great-grandfather married the heiress of King William III's Lord Chancellor, and his very wealthy wife, Margaret, who commissioned Sir Robert Smirke to build the Norman Revival building today. It is called a castle but is the private home of the Hervey-Bathursts, who inherited it when Major Hervey-Bathurst married Elizabeth, daughter of the 6th Baron, who was Chief Scout in 1944. Their son and his wife are the present owners.

The interior, mostly Gothic style, has a Pugin-designed (1851) Drawing Room with a painted ceiling and fireplace. This leads into the Octagon Room at the middle of the east front, with a compartmented ceiling recently redecorated by Laura Jeffreys. Then a door leads to the huge (60 feet × 65 feet) Great Hall remodelled by G. E. Fox, who was inspired by a Moorish banner in Toulouse Cathedral. The windows are up high. Smirke was allowed to design the wooden seats. There is another painted ceiling (1860) in the dining room. Mr Fox's work is blessed with two Italian-style fireplaces and another painted ceiling. There is a little library next door, combined with a billiard room. Here the wood carving above the fireplace is seventeenth century and comes from Reigate Priory. Pevsner says it is Grinling Gibbons' style.

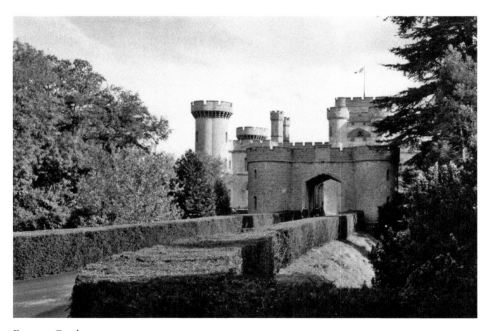

Eastnor Castle.

Upstairs there is a small chapel, unconsecrated and used for family prayers. The family tombs are mostly in St John's Church, Eastnor.

There is a painting of the 6th Lady Somers by De Lazlo – she looks remarkably like Penelope Keith. Also the Drawing Room has a portrait of the Prince Regent's friend, Lady Fitzherbert. Her niece married into the Bathurst family.

Outside there is a vegetable garden, pinetum, deer park and on the hill a 90-foot obelisk to Lt-Col. Cocks, son of the 1st Earl, who was killed at Burgos (1812) in the Napoleonic Wars. This was also designed by Smirke. The grand entrance to the house faces north-west and there are many large steps before you get to the Great Hall. The ground floor looks like a large trolly with towers in each corner in place of wheels. Only the kitchen wing, extended beyond the dining room, spoils this plan.

HELLENS MANOR
Much Marcle, Ledbury, HR8 2LY
(www.hellensmanor.com)

Close to Ledbury and at the end of a straight drive opposite St Bartholomew's Church, Much Marcle, Hellens is a Jacobean 'T'-shaped house, privately owned, belonging to the Pennington-Mellor-Munthe Charitable Trust. The Lord of Merkalanor (Much Marcle) was given it and created Earl Godwinson, but was killed at Hastings (1066), when it passed to William the Conqueror's standard bearer, Walter de Lacey. The tithes for this land went to two French monasteries and in the Domesday Book it was valued at £30, then a lot of money. It wasn't until 1180 that the name Heliun or Hellen's (the apostrophe was dropped later) became known when the Norman owner, John de Balun, gave it to his franklin (or estate manager) Walter de Helyon, whose wooden, painted effigy is in St Bartholomew's Church.

John de Balun's brother, Sir Walter, and his wife Isolde – sister of Roger Mortimer – inherited the house. She married Hugh Audley when Roger died (their effigies are also in the church). By this time Hellens was a small fortified house with a tower. In 1326 the future King Edward III came here with his mother as Roger Mortimer was possessor of the Great Seal of England from King Edward II (soon to end his life at Berkeley Castle). Walter passed the lease of the house to his daughter Joanna and her husband Richard Walwyn. (The local pub is the Walwyn Arms.)

Thomas Walwyn (Richard's grandson) introduced English bricks made from clay excavated from the estate pond. The quadrangle and tower were finished in 1451. The Walwyns were local sheriffs and entitled to hold their court at Hellens. Richard Walwyn was knighted by Mary Tudor (he was a keen Catholic) and when the family fell on bad times it was Fulke Walwyn who married Margaret Pye, wealthy daughter of Sir Walter Pye, the Attorney General. The staircase with its unusual carved beasts (griffins the guide told us, probably from a bedhead) was added by John Abel's handywork. The dovecot was built in 1641 and the house did not escape the Civil War. Walwyns were Royalists and John Walwyn, with Sir Henry Lingen, took part in the skirmish

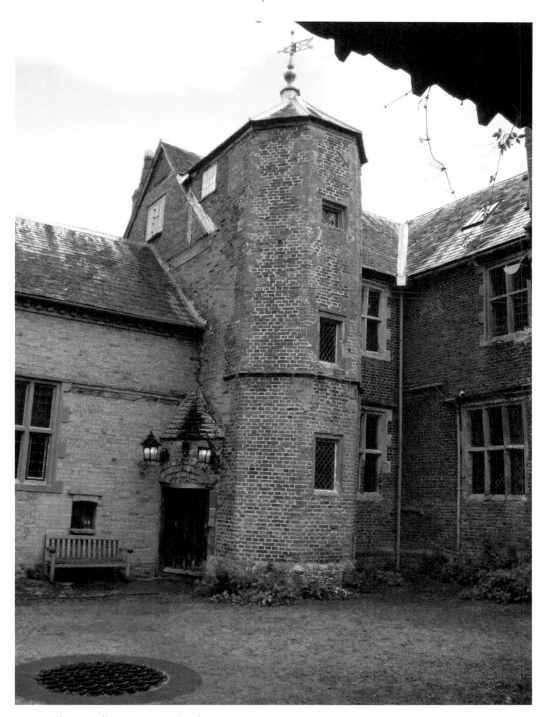

Hellens' Audley Tower. (Richard Surman)

Above: Bloody Mary's
bedchamber. (Ingalill Snitt)

Left: Hellens' entrance.
(Justine Peberdy)

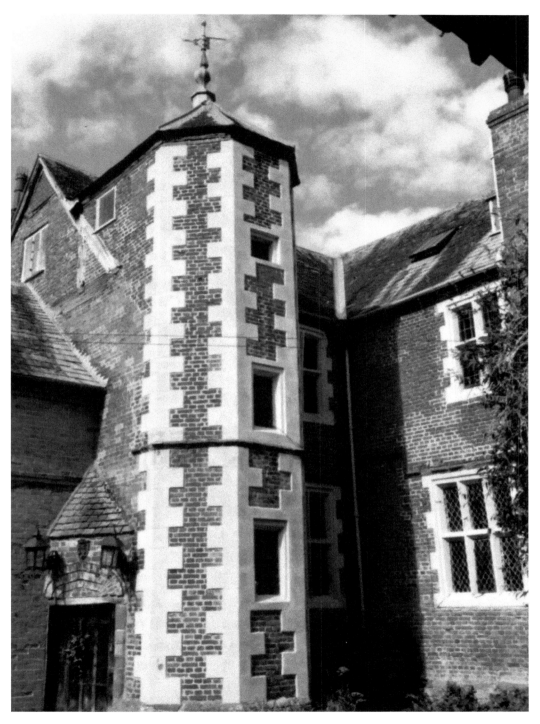

Hellens' Tower and inner entrance.

at Ledbury, where a number of Parliamentarians were killed. They got their revenge by raiding Hellens and killing the old Catholic priest there – the family had escaped.

At the Restoration, John's daughter Hetty or Bridget went mad, being shut up in her bedroom for nearly thirty years. She ran off at first with a local lad, John Piercel, but returned alone and scratched on the window: 'It is part of virtue to abstain from what we love.' The bedroom has a bell rope for the tower bell and it goes off on occasions (our guide said the rope goes through her son's tower bedroom), which leads to the reputation of the house being haunted by both Hetty and the murdered priest.

The Noble family, William was High Sheriff of the county, then took over. Windows were put in the east front and the White Drawing Room opened up. Another Walwyn relation, Charles Walwyn Radcliffe Cooke (1840–1911) then took possession, persuading Henry Weston to start his cider business in Much Marcle. Lady Gleichen, a great niece of Queen Victoria, had a cousin, Hilda Pennington Mellor (1877–1967), who married Axel Munthe, a Swedish doctor and the author of the bestseller *The Story of San Michele*, on sale in the house. The Pennington-Mellor family are still the owners today.

Pictures appeared, repairs were made, outside the music room is a fine Goble harpsichord, and Hellens has a music festival in May. The little picture of a giraffe in the Priest's Room is a reminder that in 1827 the King of Egypt gave King Charles X of France the first giraffe anyone had seen. It became an instant success and women's fashions all copied the giraffe stripes. A team of hard-worked Art Fund ladies are doing wonders with restoring chair covers and curtains. There is a modern heating system, which does not agree with the leather wall covering in the dining room. The garden has a festival in June and one of the Munthe brides went to the church in the family carriage, outside in the barn.

Don't forget to see the Boleyn comb, Sir Nicholas Kemey's diamond ring given to him by King Charles I for saving his life at Edgehill, the sixteenth-century gold hat badge that belonged to Philip, Lord Wharton – patron of Van Dyke – and the marriage coronet worn by the brides of the various families who lived here from 1540 to 1995. The Cordoba Room has a picture of Mary of Modena, second wife of King James II, a very beautiful fifteen-year-old. When James II fled to France in 1689, she had gone before and King Louis XIV repaired the road from Calais to Paris. (Our guide mentioned this and one Frenchman in the audience muttered that it is time it was re-repaired now.)

HOLME LACY HOUSE
Bridge Road, Holme Lacy, Herefordshire, HR2 6LP

Now the property of Warner Hotels, it was originally the home of the Scudamores, one of the principal families in the county. The first house was built by John Scudamore in 1571 but another John, 2nd Viscount Scudamore after his marriage in 1672, commissioned Hugh May to build the present H-shaped house, best seen from the east side. There was a western entrance but Sir Robert Lucas-Tooth, who

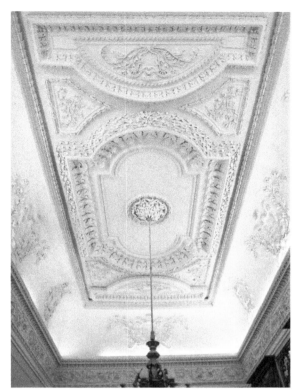

Right: The Blue Room, Holme Lacy, used today as a restaurant. The ceiling was restored in 1910/11 and Grinling Gibbons' work copied. Many of his original works went to the Metropolitan Museum in New York.

Below: Holme Lacy from the air. (Warner Hotels)

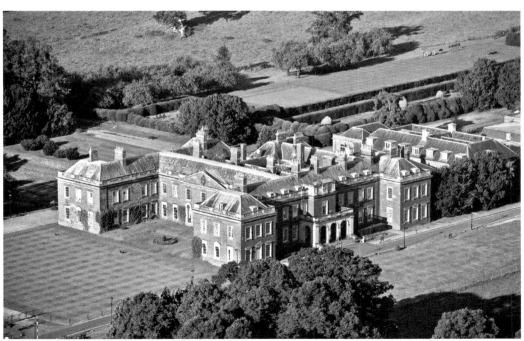

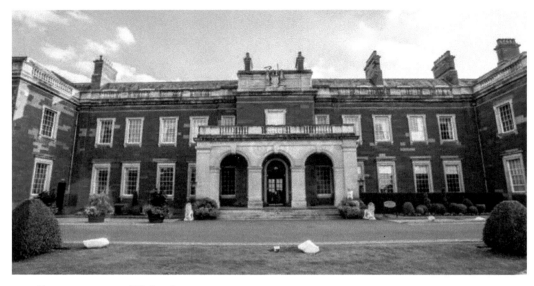

Present entrance of Holme Lacy.

purchased it in 1909, got his architects, Romaine-Walker & Jenkins, to add the ballroom (now a dining room), main staircase and a north entrance.

The fittings have mostly been removed – the house became a mental hospital between 1934 and 1981, but the plasterwork is still worth examining. Some of the original plasterwork by Grinling Gibbons was sold off to the New York Metropolitan Museum.

The hotel had extra bedrooms and service quarters fitted at the east end but they have not spoilt the house, which now has a pool and health club open at a price to local residents as well as a theatre for guests.

The Holme Lacy Scudamores are mostly buried in the church, which is about ten minutes' walk away, close to the river (it gets flooded from time to time). It now belongs to the Churches Conservation Trust and is equipped for 'champing' – i.e. people can sleep in it in the summer.

The Scudamores made their money when John Scudamore was made a 'Receiver of abbeys within the county of Hereford and others appointed to be suppressed' by King Henry VIII.

After his death in 1571 John, now Sir John, was succeeded by his grandson, another John, who lived until he was eighty-one. In King Charles' reign, this John became a viscount and began to think the church deserved something back. It was he who turned the ruined Abbey Dore into its present building as a large church. He then restored tithes for the church at some churches, including my local one at Little Birch. After the Civil War he spent his money on schools for poor children in Hereford and on repairs to the cathedral. At heart, says Fletcher, the viscount was a farmer and cider maker, as well as the introducer of the Red Streak cider apple. An anonymous poet mentions:

> ... the Red-streak that once was
> Of the sylvan kind, uncivilised, of no regard,

Till Scudamore's skilful hand
Improved her, and by courtly discipline
Taught her the savage nature to forget –
Hence called the Scudamorean plant, whose wine
Whoever tastes, let him with grateful heart
Respect that ancient loyal house.

KENTCHURCH COURT
Pontrilas, HR2 0DB
Mrs J. Lucas-Scudamore
(www.kentchurchcourt.co.uk)

Originally a fortified manor built in the fourteenth century for Sir John Scudamore (whose wife was a daughter of Owain Glyndwr), Kentchurch has a three-storey tower with a chapel and the kitchen below. Andrew Keck set out the interior in the eighteenth century; then Nash put in the south-east front, with a large dining room, large drawing room and a library being the outstanding rooms. The passage between the new and old sections ends in a steep staircase.

In 1959 there was a sudden flood due to the overflowing of the local stream, heavy rain and fallen trees – the kitchen Aga moved across the floor, many library books were damaged and Sybil Lucas-Scudamore, alone in the house, had to be

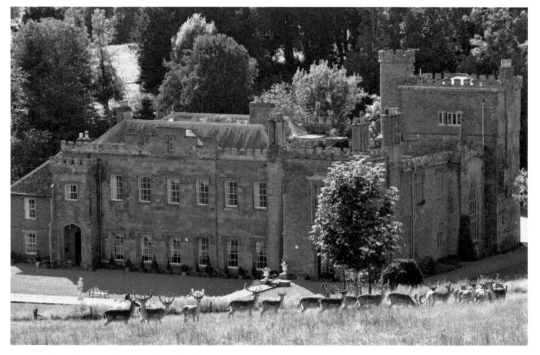

Fallow deer park. Kentchurch's three-storey tower is on the right.

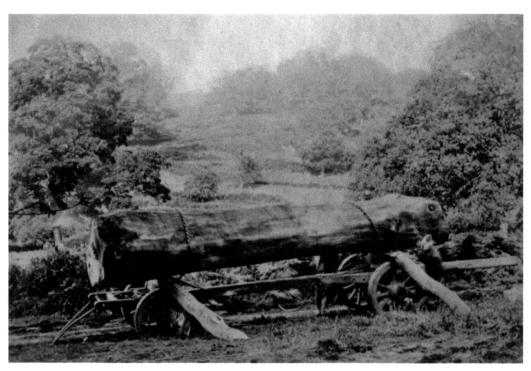

Hauling logs in Kentchurch Park. (Herefordshire Archives)

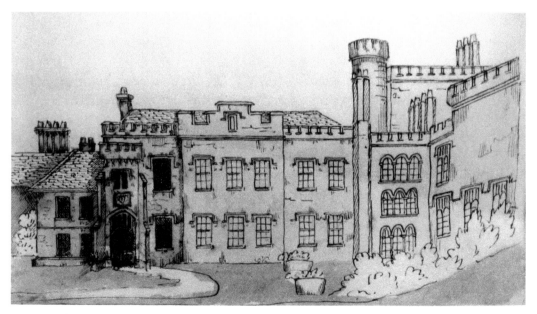

Kentchurch Court in the 1820s as depicted by James Gregory Peene in *Churches and Mansions in South Herefordshire*.

rescued. Curtains and carpets were removed through windows by tractor and rope, but it took two years before the house was dry enough to be lived in again.

Famous people who have signed the visitor's book include George Bernard Shaw and Baden-Powell, as well as more recent names of note.

Today the house's gardens are open in the summer for car rallies and coach parties.

SUFTON COURT
Mordiford, HR1 4LU

Home of the Hereford family, Sufton is perched on a hill overlooking the valley of the River Lugg just where it joins the River Wye. The area is often flooded but James Wyatt, who built the house in 1788, with grounds laid out by Humphry Repton, made sure the building was up a steep hill. Coach drivers beware as the gates are very narrow. The first time we went everyone had to walk from the coach as the driver was taking no chances.

The front is rather indistinct due to the window glazing bars being removed and a small Victorian glass porch covering the front door. The small hall has a drawing room on the left, once the music room, as there are instruments on the plaster frieze. The right-hand room is the former library. Repton did not want any room to have identical views with another. His red book, or a replica of it, can be seen and the four main rooms have attractive white and green marble fireplaces.

Sufton Court.

Pevsner points out that the gardens were laid out as recently as 1991 by Hilary Taylor. Unfortunately, we have been to the house on two occasions in pouring rain so never managed to see them.

Old Sufton, about half a mile away towards Dormington, where the family used to live, has Elizabethan chimneys similar to those at Upton Cressett, some nice eighteenth-century wooden panelling and a walled garden going uphill with a circular dovecot converted into a summerhouse.

One of the Hereford family, Nicholas de Hereford, is supposed to have told Samson's mother she should not drink cider so that he became very strong when he was born. The Herefords were also entitled to payment of a set of gold spurs every time a King of England crossed Mordiford bridge. In 1304 this became an annual rent at Michaelmas of a pair of gilt spurs valued at sixpence. By the end of that century, the value had increased to three shillings and fourpence. Arthur Mee disputes this and says that it was the Herefords who had to give the king spurs, but Revd Robinson and Fletcher both say that it was the other way round.

Shropshire

Attingham Park
Atcham, Shropshire, SY4 4TP
(www.nationaltrust.org.uk/attingham-park)

Attingham was built by the Scottish architect George Steuart for Noel Hill, later made Lord Berwick, who was the son of a banker and inherited Tern Hill, which he didn't think was grand enough. Steuart is the architect of St Chad's Church in Shrewsbury and he also built other houses in Shropshire which have not survived. The park was reorganised by Repton with a decorated bridge over the Severn.

Steuart's new house is in best Georgian style; it has an Adam style central three-storey house with ionic pillars with colonnades to left and right leading to pavilions, which create a magnificent view from the grounds. In 1807, John Nash was employed to build the internal staircase and picture gallery.

The interior is a bit his and hers. Lord Berwick and his two libraries has a red dining room with white overmantels and door surrounds. Lady Berwick has a blue and gilt drawing room with a large glass chandelier. There are pictures by Angelica Kaufman, but Christopher Hussey points out that she left the country as Madame Zucchi in 1781 and that Biaggio Rebecca may have been employed for decorating the Round Boudoir and the Octagon room.

Forbes Adam and Mary Mauchline in *Country Life* (3 July 1992) write:

> Attingham's western state rooms can fairly be regarded as one of the leading repositories of Kauffman's work in England. The first Lord Berwick chose decorative paintings and fireplaces after designs by (Angelica) Kauffman, while his son commissioned mythological paintings. Although the 2nd Lord Berwick ruined himself in the enhancement of Attingham, his younger brother William, at the enforced sale in 1827, was able to buy the Kauffman works so that the mythological subjects have always hung in the same place since their arrival there in the 1790's.

Lord Berwick ran out of money, perhaps due to taking an extravagant second wife, so in 1827 there was a three-day sale of the contents of the house. William Hill, next Lord Berwick, Ambassador to Naples, brought a lot of Italian paintings, when he died in 1842 unmarried, a third brother succeeded and the 8th Lord Berwick took over at war time, giving the house to the National Trust.

The National Trust leased it to Shropshire County Council and in the 1960s it became a centre for residential art appreciation courses. One was for young Americans working in galleries or as architects. In 1964 I was privileged to go on

one of these courses – along with ten Americans and one bearded Englishman who worked for the British Museum. I recall playing croquet on the lawn in helmets (many from the Civil War) and visiting numerous country houses in the neighbourhood. The accommodation was excellent and visiting speakers on glass, china and silver were very often contributors to *Country Life*, whose books I was helping to design.

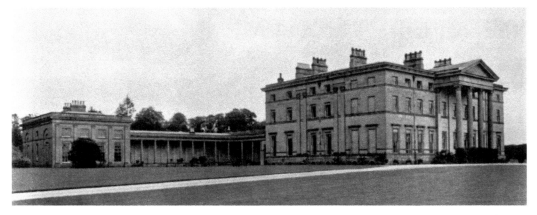

Attingham Park from the south-west with the western pavillion and colonnade. (Country Life Picture Library)

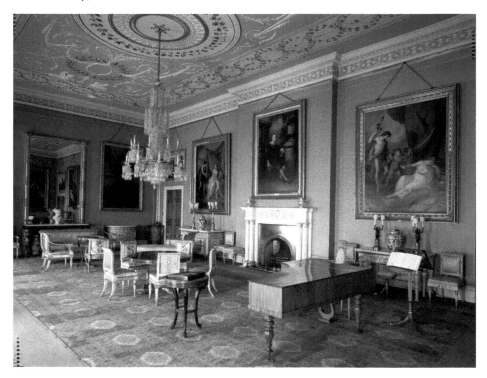

The drawing room. (Country Life Picture Library)

BENTHALL HALL

Broseley, Shropshire, TF12 5RX
(www.nationaltrust.org.uk/place/benthall-hall)

As Sunnycroft is not far away, people often couple it with nearby Benthall Hall, a stone house dating to 1583. There are the initials LBK on the porch as the builder, Lawrence Benthall, also had a grandson, Lawrence, who married Katherine Cassy. They were responsible for much of the decoration inside the house. The Jacobean hall fireplace celebrates this wedding, the leopard for Benthall and the wyvern for Cassy.

The Benthalls were Roman Catholics and there are five marks on the door to show that Catholic priests were welcome. As Simon Jenkins reminds us, the jingle goes 'Five for the symbols at your door'. There is also above the porch a false floor for communion vessels and a lookout post to see whether visitors were friendly or otherwise. The early great chamber is now the drawing room, which has a Georgian fireplace by T. F. Pritchard and a wainscot with a plaster frieze and grotesque showing many different beasts. There is a two-storey staircase that has yet more beasts on boards hiding the treads.

The garden front has five gables with double Elizabethan thick chimneys at each end with two from the front in the middle. Paths take you through the park. There is an Elizabethan skittle alley and alas the church was shut for repairs when we called. Note that the south doorway has been replaced by a stone lion's head. The lion has a pierced mouth so it could be used as a peephole. (See Judges 14 (5–18) or an old-fashioned golden syrup tin: 'out of the lion comes forth sweetness'.) Burnt down in the Civil War, like that at Stokesay Castle, it was rebuilt. Inside is a modern tomb (1996) to the Benthall family by Richard Kindersley, plus some box pews and a Restoration west gallery.

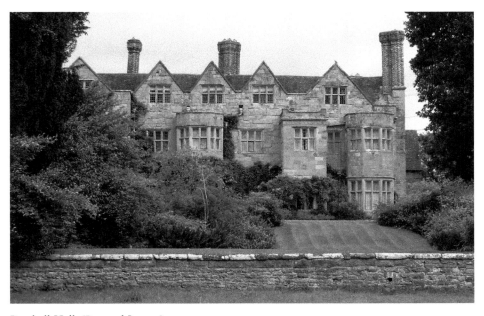

Benthall Hall. (Bernard Lowry)

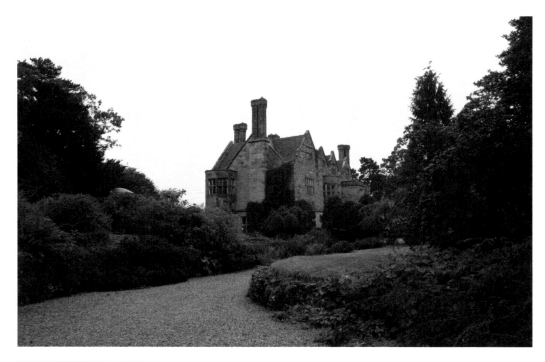

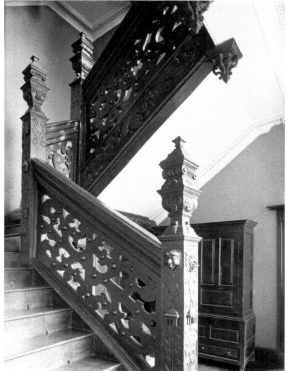

Above: The north view of Benthall Hall.
(Glen Bowman, CC-by-SA 2.0)

Left: The staircase.

BOSCOBEL HOUSE

Bishopswood, Brewood, Staffordshire, ST19 9AR
(www.english-heritage.org.uk)

Made famous as the first hiding place of King Charles II after the Battle of
Worcester (3 September 1651), Boscobel is a hunting lodge in wooded countryside.
The king was led by Charles Giffard, who knew the area well. At 4.00 a.m. next
morning they reached Whiteladies (now only a ruined priory, but then a black and
white house) belonging to the Giffords, but lived in by the Penderell brothers, one
of whom was the bailiff. The exhausted king was given George Penderell's green
cloth trousers, leather coat and his hair was cut and his face browned with walnut
leaf juice. He was now Will Jones and given a wood bill. The weather was wet and
Colonel Carless, who had been in the Royalist rear guard at Worcester, helped him
up the famous Boscobel oak tree where they spent the day.

Bookplate with the arms of the Penderel brothers of Boscobel showing the Royal Oak and
Three Crowns.

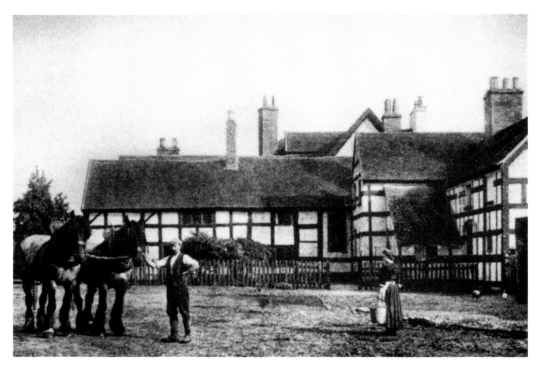

Boscobel in 1910.

Boscobel House was mostly rebuilt by the Evans family, owners in the nineteenth century. The stable is complete and the farmhouse mostly nineteenth century, though painted black and white. The hunting lodge next door is now white too and rather spoils the view. Charles was hidden in a priest hole after a mutton supper and the following day he was taken by Carless and the Penderells safely to Colonel Wilmot's home at Moseley. After more adventures, he eventually arrived at Shoreham where he and Wilmot boarded a coal boat, the *Surprise*, which took them safely to France.

Whiteladies is a twenty-minute walk from Boscobel where the garden is being altered to include plants used for seventeenth-century dyes and medicines with vegetables that might have grown in those days. There will be a blacksmith and a cider press and a new café and the Victorian farm has hens, sheep and pigs.

Boscobel closed in 2020 while there was much tree planting going on in the field with the Royal Oak, for in Charles' time it was one of many. It reopened again in 2021.

NB: Boscobel is geographically in Shropshire, but the postal address is Staffordshire.

DUDMASTON
Quatt, Bridgnorth, WV15 6QN
(dudmaston@nationaltrust.org.uk)

A William and Mary-style house built by Sir Thomas Wolryche in *c.* 1690, Dudmaston has nine bays front and back. Today it is a National Trust property,

but only since 1979. In this year, Sir George and Lady Labouchere had a great part in founding the Ironbridge Gorge Museum, of which Lady Labouchere became president.

The roof and top storey were added, according to Pevsner, to the design of John Smalman of Quatford. It is possible he had advice from Smith of Warwick for the magnificent cantilevered staircase and the library (made out of two rooms) with its recessed bookcases are very special.

The Whitmores (the family name became Wolryche-Whitmore) represented Bridgnorth for 194 years as Tories between 1661 and 1870 – one became a Whig and supported Catholic emancipation but later stood for Wolverhampton. Sir George became the Ambassador to Belgium in 1955 – fortunately long before the EU – so he had time to collect paintings by Matisse, Dubuffet and Max Ernst. Lady Labouchere inherited all the Darby flower paintings and Darby papers, etc., and in the garden there are modern statues, notably a bronze bird by Feliciano, which looks as if it had been conjured up by Aladdin from his magic lamp.

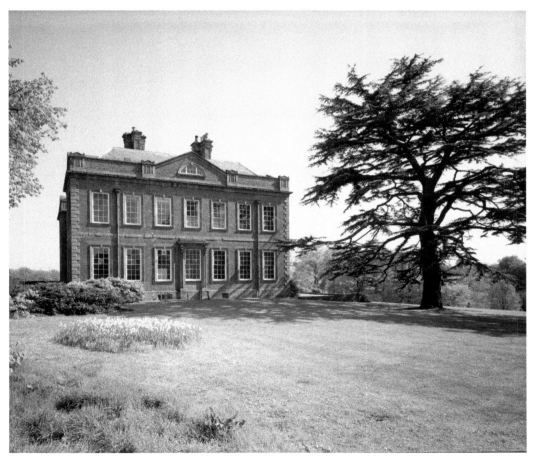

Dudmaston. (Country Life Picture Library)

Dudmaston. (Bernard Lowry)

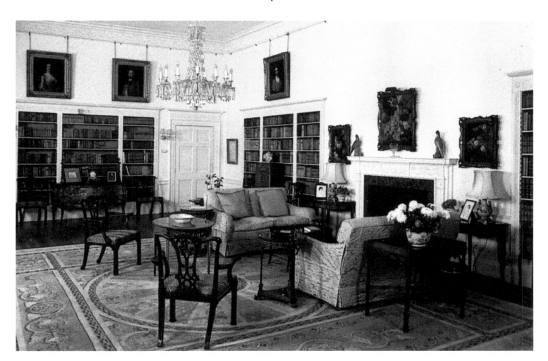

Above: The library. (National Trust)

Right: The main staircase. (Country Life Picture Library)

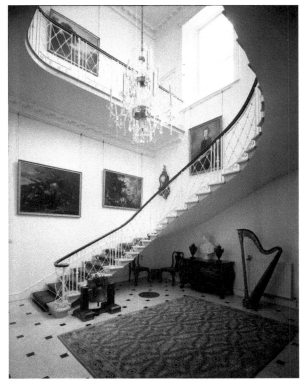

Inside nearby Quatt church there is a monument to Francis Wolryche (1614) and his wife and to Sir Thomas (1668) and Sir Francis (1689), as well as a marble statue of Mary Wolryche (1678) propped on a pillow holding a lute. Most of the church was reconstructed in 1763.

There is a huge park and lake, which were created by Walter Wood, who was known to William Whitmore's wife in *c.* 1770. There are some good walks in the estate and the art gallery and tearoom are also big attractions.

LONGNER HALL (HH)
Atcham, SY4 4TG

Not to be confused with Longnor Hall, a Corbett home of the seventeenth century, off the A49 between Dorrington and Leebotwood, Longner is the home of the Burton family, whom Repton tried to persuade to keep their Elizabethan house, but they were happy to have a Repton park, though they commissioned Nash to build the hall in Gothic style. Inside, it surprises as it has a fan-vaulted passage and three large figures in stained glass above the staircase, dated 1808. They are King Edward IV and Sir Edward Burton and Protestant Richard Burton, who 'died of joy' when Queen Mary Tudor died. He is buried in the garden as

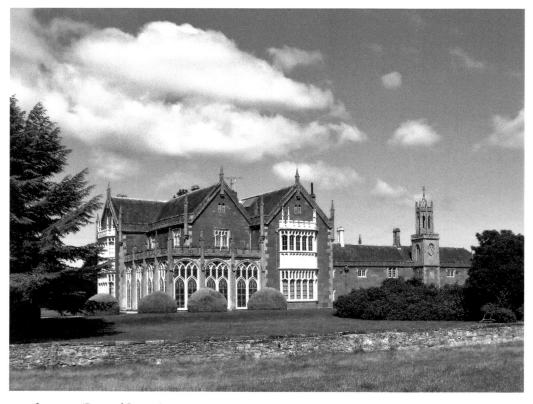

Longner. (Bernard Lowry)

St Chad's, Shrewsbury, refused to bury him. There is an octagonal game larder (1842). Pevsner points out that there is a castellated cottage on the edge of the park opposite one in Attingham's park.

PITCHFORD HALL (HH)
Near Condover, Shropshire, SY5 7DN
Mr and Mrs Nason

Pitchford has been called the best black and white house in Shropshire. This is a misnomer – closer up the woodwork of Pitchford Hall today is brown. In the grounds there are remains of a pitch well, where wooden beams could have been covered by natural pitch, so maybe it was black but is now brown. The well is by the Row Brook, which has a ford east of the bridge, hence the name. A Roman sword was found in the grounds in 1898. In the Domesday Book it was held as three manors with land for five ploughs and woodland for 100 pigs. In 1086 it was held by Sir Ralph de Pytchford. In 1211 another Ralph built the church. In 1473 it was purchased by Sir Thomas Ottley, whose family held it until 1807.

Nowadays the entrance is at the north side, so one can see the length of the house. The left-hand side is mid-sixteenth century, with some later additions, and the right-hand side is a service wing of brick and sash windows, which George Devey reshaped and 'Tudorised' so it looks in keeping with the rest of the house.

On the south side you can see the house is F-shaped and the original entrance is in the centre. At one time there was a wall across the two wings as a road ran past. Our guide did say this was tied up with the mill and the mill race but did not last long. Looking at the clock tower the left side is the original house and the right built to fit in the 'Shrewsbury style'. The west wing is thought to have been an open hall similar to that at Stokesay. The right-hand side was built by John Sandford in 1575. He was a local carpenter, who used the 'jetty' system so that the bressummer beams and barge boards were carved and tie beams had vine leaf patterns. Gable ends were jettied out so that the staircase adds to the strength of the first floor. Grope Lane in the centre of Shrewsbury is a fine example of this system.

During the Civil War, Prince Rupert hid in the priest's hole in the upstairs drawing room. This now has no floor and a ladder and outside door gives a means of getting in and out for someone in a hurry.

The Ottleys ran out of male heirs, so the hall passed to Charles Cecil Cope Jenkinson, a half-brother to the Prime Minister Lord Liverpool at the time of Waterloo. Improvements were made and in 1832 the Duchess of Kent and young Princess Victoria stayed here (the bedroom Victoria slept in is used today by the young Colthursts) and the Jenkinson girls gave her a trip round the estate, watching the dairy maid make butter, picking strawberries and then climbing up into the tree house. This still stands in an ancient lime tree and is black and white with a pointed roof. Inside it would make a good place to play cards on a summer day, but it does not seem to have been used for this

purpose. Louisa, eldest daughter, married John Cotes, who spent all his money on restoring the church and house. A bachelor, on his death it went to his sister Victoria, at the age of seventy-three. She had lost her first husband, Thomas Owen, on their honeymoon of malaria. Her second was General Robert Grant.

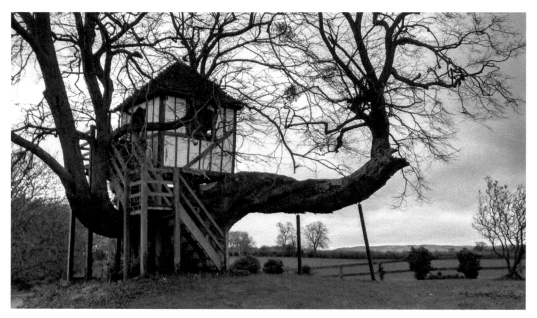

Tree house, Pitchford Hall.

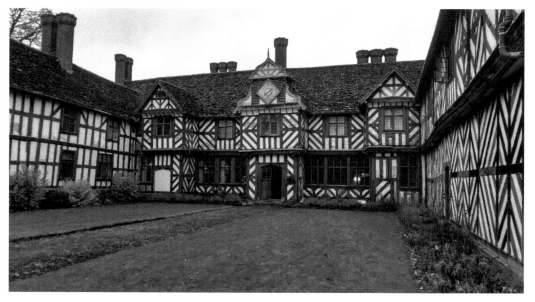

Pitchford Hall. Note the fire blazing in the main sitting room to the right as it was December.

Their daughter Margaret died at the age of five and one of her sons, Robin, was killed in the Boer War at Spion Kop, so it was General Sir Charles Grant who took over the hall. He married Sybil, daughter of the Earl of Rosebery – another prime minister. She was an eccentric and lived in the orangery, her husband in the house. They met on the lawn and sometimes she ate her meals in the tree house served by the butler on a silver salver. Charles was Governor of Edinburgh Castle and lived until 1950. The house was made an escape safety house for the royal family in 1940 in a secret plan to get them to Canada, called the 'Coats Mission'.

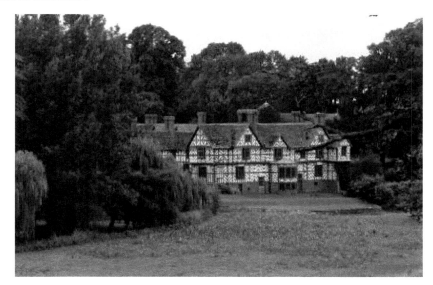

Pitchford Hall. (Bob Bowyer)

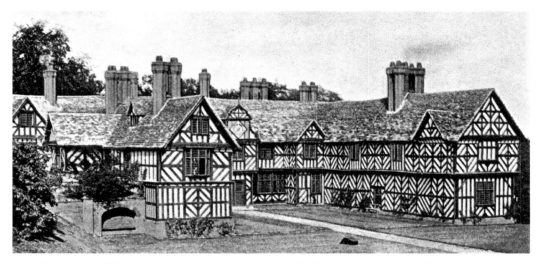

A postcard of Pitchford showing the south view and original entrance below the clock tower. The brown woodwork is very obvious compared with the picture on page 40.

The pitch well.

Robin, Charles and Sybil's only son, was disliked by his parents for reasons unknown, but he loved the hall and, with his third wife Barbara, made it into a charming family house. In 1972 their daughter Caroline married Oliver Colthurst and today their daughter Rowena and her husband James Nason and two children are the owners. They had to buy out the Kuwaiti princess (the owner after Robin lost his money at Lloyds in London) who had attempted to turn it into a stud, but rarely spent time there, so it was only in 2016 they could move in with borrowed furniture and no heating apart from the downstairs log fire. The visitor only sees five rooms, but a trip to Pitchford Hall is an experience, so choose a fine day. We went in December.

STOKESAY COURT
Near Craven Arms, Onibury, SY7 9BD
Contact: Caroline Magnus
(www.stokesaycourt.com)

Stokesay Castle is well covered by *Castles of the Marches* (Amberley, 2015), so it is with Stokesay Court we are now concerned. It is at Onibury and was built in 1889–95 for glove maker John Derby Allcroft MP. He used Thomas Harris, whose Bedstone Court had been built in 1879, and he used garden designer H. Milner, who also worked on Webb's Yeaton Peverey (off the A5 near Great Ness). The approach to the huge house is via the north-west, which brings you into a three-sided courtyard. The house is built of yellow sandstone and is more interesting on the south-eastern side, where there is a touch of the Jacobean. The entrance arch and stairs are topped by a jutting out curved-base oriel window and all is symmetrical except the owners wanted a wing to the north with separate rooms for women and men. Behind them are the large service quarters. Milner has done his best and house photographs from the fountain are probably best from this side.

When we were shown around it was after the film *Atonement* had been filmed here so we were shown Nicole Kidman's clothes and the rooms upstairs used in the film, taken from the book by Ian McEwen. In the First World War I, the Court was turned into a military hospital and was well used. The stable block is worth seeing and, like Manderston in the Scottish Borders, the stables are very luxurious for the horses. There is a clock turret but alas no silver staircase, as at Manderston, in the house, not the stables. The Edwardians looked after their horses. The stables are privately occupied and not normally open.

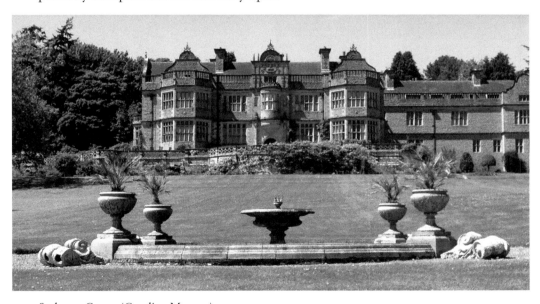

Stokesay Court. (Caroline Magnus)

A drawing of Stokesay Court.

SUNNYCROFT
No. 200 Hollyhead Road, Wellington, TF1 2DR
(www.nationaltrust.org.uk/sunnycroft)

This Victorian villa with a large garden is a most unusual National Trust house. The last owner, Mrs Joan Lander, left it to them in 1997 and the house is full of her homely items – she was a keen needlewoman – but on fine days there is a system of timed entries with a guide so that the garden has children's games and there is a small tearoom in the verandah room and the usual second-hand books for sale. Mrs Lander was chosen as a sempstress for Queen Elizabeth II's coronation gown.

This is an ideal house to visit with small children as on a fine day as there is plenty to do for them outside.

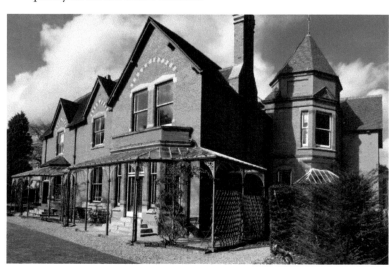

Sunnycroft.
(National Trust)

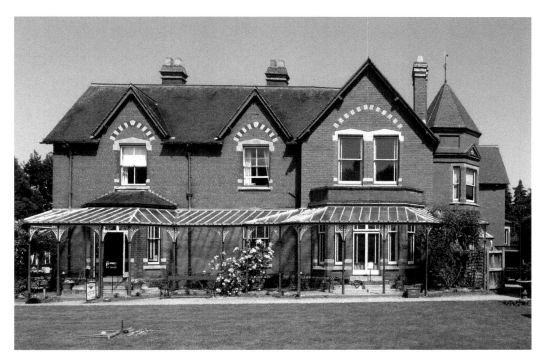

Sunnycroft.

UPTON CRESSETT HALL (HH)
Nr Bridgnorth, WV16 6UH
Owners: Mr and Mrs W. Cash
(www.uptoncressetthall.co.uk)

Basically an Elizabethan house with an elaborate gatehouse (now a self-let flat), Upton Cressett was built by Sheriff of Shropshire Richard Cressett. The dating of old timbers dates the original house to the 1430s, probably 'H' shaped, going back to an earlier Cressett, Hugh, also a sheriff and MP. However, Richard was no doubt responsible for the Elizabethan twisted chimneys and the defensive moat, and no doubt a wall, which would have made it a fortified manor, though not able to cope with being on the wrong side in the Civil War. Prince Rupert and some of his cavalry rested here in 1646. He also attended a church service in the little church at the bottom of the lawn.

Cressetts were careful to support both sides in the War of the Roses. Hugh was a Lancastrian and Constable of Mortimer Castle and his son was a Yorkist lawyer and Sheriff of Shropshire, being replaced by Gilbert Talbot after the Battle of Bosworth (1485). During the Civil War, Edward Cressett was a member of Charles I's Council and tried to rescue him from Carisbrooke Castle in 1648. Before the war, Edward established the deer park in the ground and his grandson, James, was Envoy Extraordinary to the court of Hanover for William and Mary. There was yet another Cressett who played a part in the government's difficult decisions as to what to do about the madness of King George III.

The gatehouse has a carriageway through it and this has recently been decorated by Adam Dant with an illustrated history of the Parliamentary mace. (William's father, Sir Bill Cash MP, is the Mace Bearer for Parliament.)

Adam has done more work in the house and the modern wallpaper has his decoration. The main entrance hall is in the bottom part of the fifteenth-century hall, once aisled. There is a boxed-in well and a nearby steep staircase to the main bedroom. The central room is the kitchen with a wide fireplace. The 150 roof trusses are hidden by plaster ceilings – the date 1600 can be seen on panelling – so the architectural history of the house is rather complex, but it is well worth a visit.

The Cash family purchased it from the Marsh family in 1971 and have done much work there including Adam's repainting of the dining room.

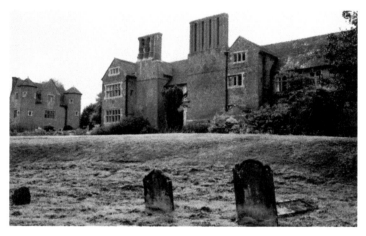

Upton Cressett Hall.

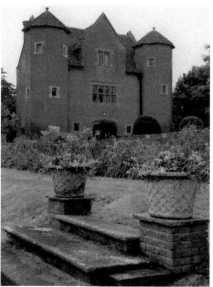

Above: Upton Cressett print.

Left: Upton Cressett gatehouse.

STAFFORDSHIRE

WESTON PARK

Weston Park Foundation, Shifnal, Shropshire, TF11 8LE
(www.weston-park.com)

Weston Park is listed under Shropshire in *Hudson's* but geographically is just in Staffordshire. The large house was designed by Lady Wilbraham in 1671. She had a copy of Palladio's *First Book of Architecture* and proceeded to design Weston herself. John Cornforth and Oliver Hill in *English Country Houses: Caroline, 1625–85*, dismiss her efforts as 'amateur'. However, the south front with eleven bays and three storeys is unique. It has a stone central bay with a large garden door and the two outer bays, left and right, have curved tops with circular medallions above the top windows and in between them there is a neat railing. It is a pity that the Earls of Bradford, later and current owners, moved the entrance to the east, presumably because they wanted a porch. Only the downstairs is available to be seen by visitors and they enter through a side door instead of the old front door in the centre of the south front (shown on the cover of this book).

It seems that research has gone on since the Cornforth & Hill book was written. Lady Wilbraham may have ruled the roost, but there is considerable argument that the real architect was Henry Taylor, a London carpenter and architect who had worked for the Thynnes of Longleat. He built Minsterley church (1688) (see *Churches of the Marches*) and may well have come to the notice of the Wilbrahams, and the church has some stylistic affinities with the completed building. Looking at houses built during the same period, Tyttenhanger, a nine-bay, seventeenth-century house in Hertfordshire, was probably Peter Mills, who was one of the four surveyors to be appointed to rebuild the city of London after the Great Fire (1666) along with Wren, Pratt and Hay. Pratt's great house, Thorpe Hall, has only nine bays and was built in 1653. It certainly doesn't have the character of Weston Park.

The park is by Capability Brown, but his park has a great number of temples by James Paine, notably the Temple of Diana, which has artwork by Colombe. This is now joined onto the tearoom, but Paine's Roman Bridge, Swiss Cottage, Mausoleum and his boat houses on the lake are worth seeing. Inside, Weston has lots of classical columns and some valuable pictures. One Earl of Bradford was Queen Victoria's Master of Horse. The old library (now the entrance room) has pictures of horses and a Holbein in a small room next door. Lady Wilbraham's central open courtyard (Croft still has one) was converted into a billiard room

and grand hall full of Chinese porcelain and pictures by Rosa and Bassano. The large dining room with pictures by Lely, Kneller and Van Dyck include one by Sir Thomas Killigrew, who created the Theatre Royal, the first to allow women on the stage. Lady W appears at last in the drawing room (Jenkins says she looks 'most determined') and then there is a tapestry room, with Gobelins from 1766, framed, by Rubens, Watteau and others. Jonathan Hocke, joiner of the Chirk Long Gallery, left a note saying 'A trip to Weston to get my Lady Wilbraham's direccons about the Great Room in the Bell Tower.' Hooke must have worked at Weston.

Lady Bradford was a friend of Disraeli, who sent her a parrot with a sad letter ending with the words 'I have had at least my dream, and if my shattered energies never rally, which is what I want I must be prepared for, I have at least reached the pinnacle of power.'

Lady Bradford had the parrot stuffed and caged. It can be seen in the drawing room and is bright yellow, which was of course Diraeli's favourite colour. It only lived a short life during which it laid a lot of eggs, then dropped down dead.

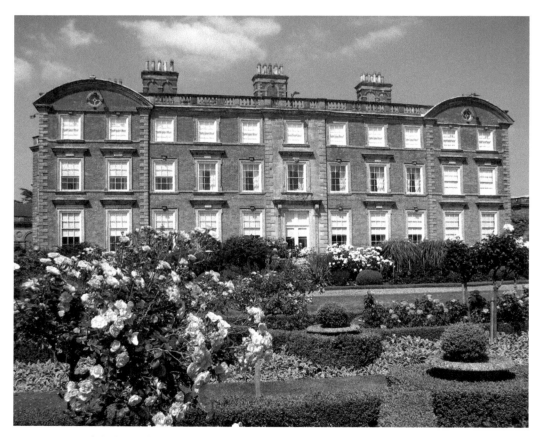

Exterior of the house from the Rose Garden. (Gareth Williams)

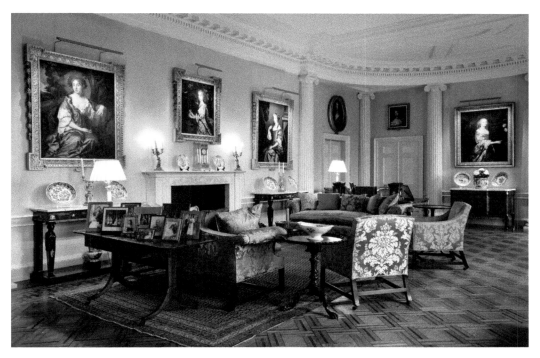

The drawing room. (The Trustees of the Weston Park Foundation)

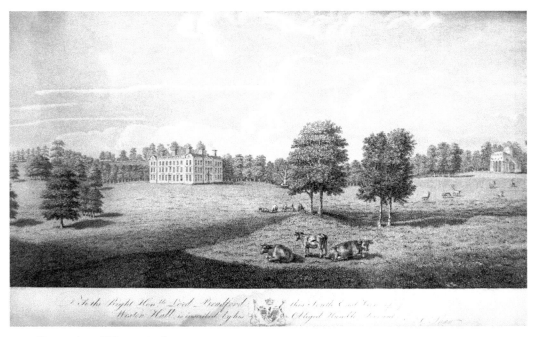

Shaw print of Weston Park.

GLOUCESTERSHIRE

FRAMPTON COURT
Frampton-on-Severn, Glos, GL2 7EP
Contacts: Mr & Mrs R. Clifford
(www.framptoncourtestate.co.uk)

Just off the A38 between Tewkesbury and Bristol, this is a Clifford house, rebuilt in
1731. The owner then, Richard Clutterbuck, a local customs man, probably used
John Strahan, a Bristol architect, but this is not definite. The result is a mixture
of Palladian and baroque. The front has Ionic pilasters with a pediment showing
the Clutterbuck arms crossed with that of the Cliffords. The chimneys seem over
large, but maybe they are ones that carry smoke well away.

Inside, the main staircase on the left is made of different woods including holly.
There is a fancy dog gate that folds outwards, perhaps for both dogs and children.
There is oak panelling in both dining and drawing rooms, which look onto the
garden front and fireplaces have Delft tiles. The bedrooms have wooden panelling,
some by William James (1823–27).

Clutterbuck improved the park with a canal, orangery and some impressive
gate piers.

On the other side of the green is Frampton Manor, supposed to be the birthplace
of 'Fair Rosamund' Clifford, mistress to King Henry II. The court is open to those

Frampton Court, 1732.

who pay for bed and breakfast and self-catering, and has an interesting sixteenth-century barn, once a wool house, plus a dovecote. Worth seeing too are the Clifford and Clutterbuck monuments in St Mary's Church at the south side of the village. If you like churches, you are not far from the exciting Saxon church of Deerhurst, Odda's Chapel (even nearer the river) and the brass to 'Terri' the dog (see *Churches of the Marches*).

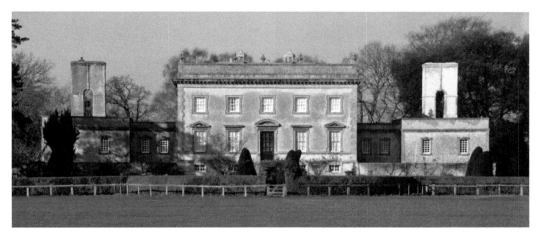

Above: Frampton Court today. (Philip Halling)

Right: The Orangery. (Roger May)

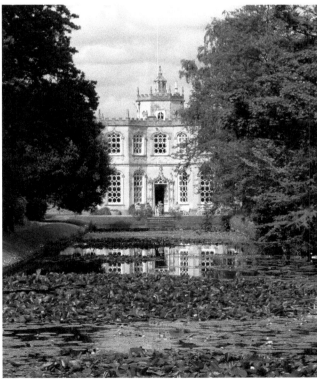

BRECONSHIRE

TRETOWER COURT (CADW)

Crickhowell, NP8 1RD

(www.cadw.wales.gov.uk)

Easily found a few miles from Crickhowell, just off the A40 going west – the turning is close to an old AA box. There is a tall tower of the same type as Skenfrith Castle (see *Castles of the Marches*) erected by Roger Picard and his son and finished around 1180. After the original tower was knocked down by the Earl of Pembroke in 1233, Roger (the son) rebuilt this tower as we see it today, three storeys with a wooden fighting top for archers, the stairs to the first floor being inside the tower wall like a Scottish *broch*. It would help, especially on a wet day, if there was a rope on the outside of the stair to help the public to climb them. The two living rooms had massive fireplaces and there was an ingenious roofed bridge for the guards on the wall, much heightened by Picard II. An artist's impression by Terry Ball makes it look like Caerlaverock's triangular bailey castle with moat and outer gateway.

However, it is with Tretower Court we are concerned. William Herbert, later Earl of Pembroke, an ardent Yorkist, passed it to his stepson Roger Vaughan, whose father had been killed at the Battle of Agincourt in 1415. Vaughan, with the help of half-brother William, who took the name Herbert, built the square-shaped court about 200 yards east of the castle. The entrance from the road is a small porch with a wall walk over, all of stone with rubble walls and a gallery round the courtyard. The Great Hall has been restored with a medieval lunch laid out (the soup looks a bit cold now) on three tables with a modern cloth picture showing Agincourt, the appearance of three suns at Mortimer's Cross (1461) where both half-brothers fought for the Yorkists and the last picture shows Sir Roger and Lord William at the Siege of Harlech Castle (1468).

The red and dark blue striped wall above the massive fireplace and shuttered window is a CADW decoration, which probably covers up some uneven wall work. This work was done in 2009–10, so the visitor can walk into the buttery, screens passage, then the great hall with its impressive arched braced trusses and trefoiled wind braces. Lighting would have been by candles and the great fireplace.

The withdrawing room window is stone, a window of four lights, decorated externally and provides a prop for the walkway above. The last improvements by the Vaughans may have included the roofing over the south walkway. The last Vaughan, Vaughan Morgan, who died in 1684, was responsible for this, and

in 1786 the buildings were all taken over by farmers (who still farm inside the walls of the castle). The Brecknock Society purchased the buildings in 1930 (the Court was in a ruinous condition then) and transferred them to the Ministry of Works, whose ancient signs still stand, before they transferred them to CADW. For visitors on a hot day, tea is available in the shop but there is no café and visitors are advised to bring their own picnics.

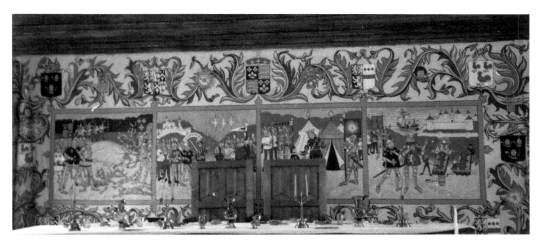

Mural at Tretower.

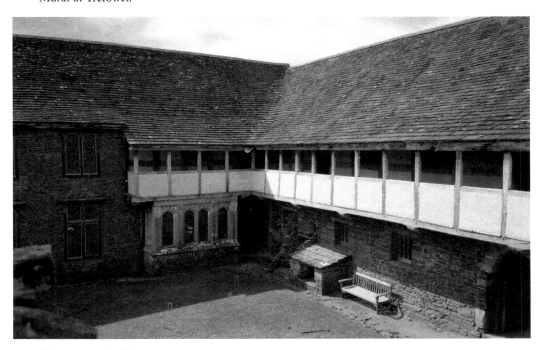

The courtyard of Tretower.

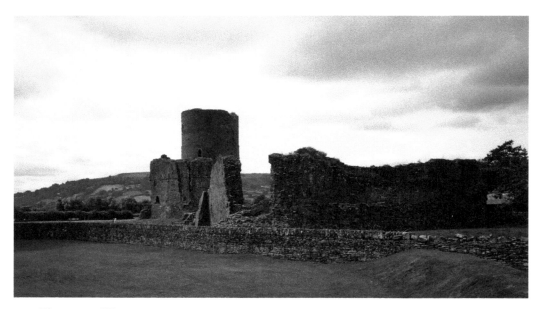

The tower of Tretower.

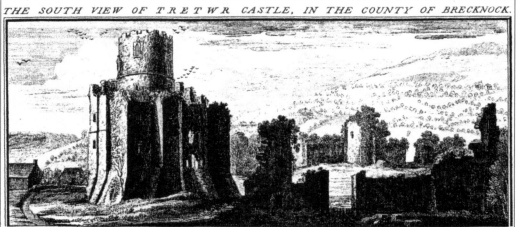

Tretower Castle. Print from when it belonged to Lord Arthur Somerset, probably *c.* 1750.

MONMOUTHSHIRE

CORNWALL HOUSE (HH)
No. 58 Monnow Street, Monmouth, NP25 3EN
www.historichouses.org

This is a large Georgian house, painted yellow, set back from the main shopping street with a metal gate and fence, covered with tall hollyhocks. Cornwall House is late eighteenth century and the rear face, very different, dates from 1750. Erected by Henry de Burgh, agent to the Duke of Beaufort, it was purchased by Jane Harvey's grandfather in 1905. However, in 1860 the Matthews family divided it into two and it became associated with the shop on the town side. Our guide was brought up here and showed us the 1923 flood mark five steps up on the garden side. She said that when the Wye and the Monnow flooded they had flood water on both sides of the house.

There is a fine nineteenth-century staircase going up to the floor above, then a very steep stair up to the top floor. Here one can see the street below and a Treowen oak floor. The two houses are connected as Jane and her husband, John

View of Cornwall House from the front.

View of the rear garden of Cornwall House.

Wheelock, prefer the comfort of Cornwall House to the austere living quarters at Treowen.

The Adam fireplace is in the next door's house but the doors between the two are now well-filled bookcases and the dining room has some blue and white pieces of Royal Copenhagen china. The study has a grandfather clock from the Treowen collection.

THE KYMIN & THE NAVAL TEMPLE
Monmouth, NP25 3SF
(www.nationaltrust.org.uk/the-kymin)

This is a round, crenellated tower, painted white, on 13 acres of National Trust land, which is accessed by a narrow zig-zag lane across the Wye bridge and off the windy road leading into the Forest of Dean (A4136).

The round tower was constructed in 1794. The lower part is a kitchen and the upper part the lookout, but originally a dining room. Admiral Nelson and Lady Hamilton came here in 1802 and were given a public breakfast (as well as the Freedom of Monmouth). The little Naval Temple was originally built in 1800 in memory of 'the naval heroes who made the name of England famous in the French Wars'. It was dedicated to the Duchess of Beaufort, daughter of Admiral Boscawen – known in the Royal Navy as 'Old Dreadnought'. On a fine day, the Kymin is ideal for picnics or bluebell walks in the spring.

The Kymin. (J. S. N. Kinross)

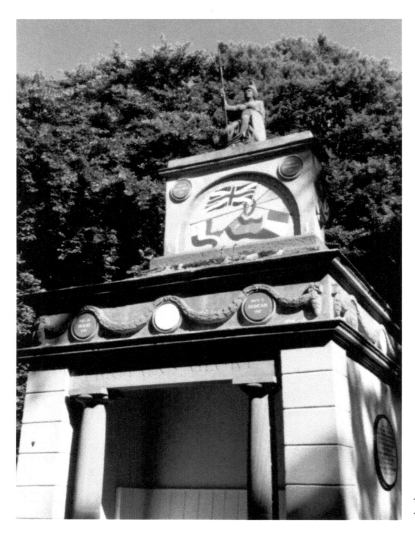

The Kymin Naval
Temple.

LLANTHONY PRIORY (CADW)
Llanthony Priory, Abergavenny, NP7 7NN
(www.cadw.gov.wales/visit/places-to-visit/llanthony-priory)

Well signposted off the main road between Hereford and Abergavenny, Llanthony
is today a ruin apart from the undercroft, which was converted into a small pub-
cum-guesthouse, and the infirmary, which was converted into St David's Church. I
first discovered it when doing the Offa's Dyke walk from Chepstow with an older
colleague and we dropped down from the hill above to spend the night there. My
room was at the top of a spiral stair and I had to climb it on all fours.

 St David is supposed to have built a chapel here. This was discovered by one of
William Rufus's knights while out hunting. He decided to end his days here as a

hermit, joined later by Queen Maud's chaplain, Ernisius. Hugh de Lacy endowed them with land and between 1108 and 1136, the priory was built, with canons coming from London and Colchester following the St Augustine rules.

Unfortunately, there was a much more comfortable priory in Gloucester where many decided to go to as it was supported financially by the Earl of Hereford. Thus the existing building fell into ruins. When Francis Kilvert visited it in 1870 it was already a tourist spot.

> Of all noxious animals too the most noxious is a tourist. No wonder dogs fly at them ... we were hungry and our ham and eggs fried were very acceptable ... good bread, cheese and butter and fair beer for which we paid 2 shillings each. The tourists had kept us for an hour waiting for our food so we did not start to leave till 3.50. We came into the sunshine directely we surmounted the Bwlch (hill above Hay) ... in their walks William and Dorothy Wordsworth crossed the mountain by this pass ... no sound except the shepherds calling to their dogs about the hills. Morrel and I arrived at Clyro 7.50 and ... were rather tired with our 25 miles walk, but not extraordinarily so.

Another nineteenth-century visitor was the poet Walter Savage Landor, who built a house nearby (now a ruin) and planted many trees before leaving for Jersey. He did not like the climate.

> Llanthony: an ungenial clime
> And the broad wing of restless time

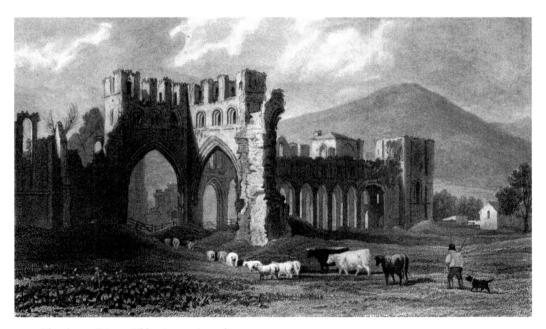

Llanthony Priory. Old print, artist unknown.

Have rudely swept thy mossy walls
And rocked the abbots in their palls.
I loved thee by thy streams of yore;
By distant streams I love thee more;
For never is the heart so true
As bidding what we love adieu.

Today's Llanthony is still a tourist spot worth a visit. The pub still provides beer, cheese and eggs. There are more cars than walkers. Many are going on to the tiny church of Capel-y-Ffin, with its connections with Eric Gill, and over the steep pass that ends at Hay-on-Wye.

LLANVIHANGEL COURT

Llanvihangel Crucorney, Nr Abergavenny, NP7 8DH
Mrs J. Johnson
(www.llanvihangelcourt.com)

'Llanvihangel' means 'the Church of St Michael' in Welsh.

The basically Tudor house is off the A465 road in the village of Llanvihangel Crucorney. The house was first mentioned in records during the reign of Henry VI (1422–71) when it would have been an open halled house belonging to Thomas ap John ap Gwillim Jenkin, the second son of a family who lived at Werndu near Abergavenny.

His granddaughter Janet married Philip Herbert, illegitimate son of the 1st Earl of Pembroke. Their granddaughter married William Morgan of Triley and it was their son Rhys Morgan, who rebuilt the east front of the house in 1559. Anthony, son of Rhys, sold the court to Edward Somerset, 4th Earl of Worcester, in 1608. The house was extended, possibly during the ownership of the Earl of Worcester, and the great hall and west wing were added. The main entrance to the house was through a door in the west side of the hall, which led into a screens passage.

The earl owned the court for twenty years and on his death it was sold to Nicholas Arnold. He was the grandson of the Sir Nicholas Arnold, who lived at Llanthony Abbey, which he had acquired at the Dissolution of the Monasteries.

The Arnolds made some changes by moving the front door to the central position, thus making a grander entrance, changing the windows to long mullioned stone ones and adding a magnificent yew staircase.

Nicholas' great interest was breeding horses and he was probably responsible for building the stables, which have bee skep shaped tops on the turned wooden pillars.

In 1665 John Arnold inherited the estate from his father and in 1669 became High Sheriff. He was a rabid Protestant, which brought him into conflict with the Catholic Herberts of Coldbrook and the Marquis of Worcester at Raglan Castle and was also much disliked locally.

He was responsible for the arrest of Father David Lewis, a much-loved Roman Catholic priest, at Llantarnam in 1678, whom he brought to Llanvihangel to spend the night 'in an upper room' before moving him on to prison in Monmouth. David Lewis was hanged at Porth y Carne in Usk in 1679.

The following year a John Giles attempted to murder John Arnold by stabbing him in Bell Yard, London, which he would have succeeded in doing had Arnold not been wearing armour at the time. Shortly after this, the Duke of Beaufort took John Arnold to court in the King's Bench for *Scandalum Magnatum*, of which he was found guilty and fined £10,000, a huge sum of money in those days.

After his death in 1721, his daughters sold the house and estates to Edward Harley of Brampton Bryan, Herefordshire. It was sold again in 1801 to Hugh Powell, treasurer of St Bartholomew's Hospital, who left it in 1821 to his godson, the Hon William Powell Rodney, who came from Berrington Hall. Mr Rodney lived here until 1878. It was let until sold to Mr and Mrs Atwood Matthews in 1903. There is a monument to him in the church saying he was a co-founder of the Alpine Club. He died before moving in and Mrs Atwood Matthews lived here until 1924, building many additions to the house and installing the stained glass windows by Dudley Forsyth, depicting Charles I (who may have visited during the Civil War, leaving behind his coat of arms), and Queen Elizabeth I with Sir Walter Raleigh.

The next owners, the Bennetts, were here during the last war. They removed the additions made by Mrs Atwood Matthews, returning the house to its original form.

After Mr Bennett's death, the house was sold to Col. and Mrs Hopkinson.

Outside, the house is approached by a stone staircase and the terraces, which were probably built by the Arnolds in the seventeenth century. There is a round

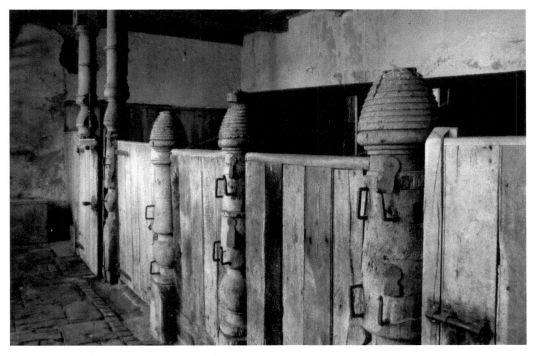

Beehive stable posts. (R. W. Johnson)

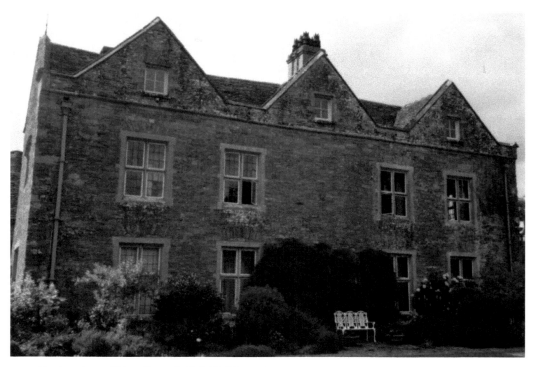

Garden view of Llanvihangel. (J. S. N. Kinross)

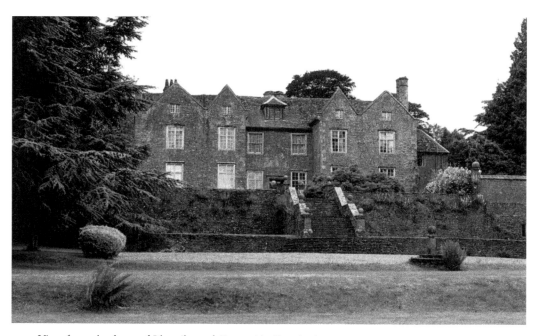

View from the front of Llanvihangel Court. (A. Copping)

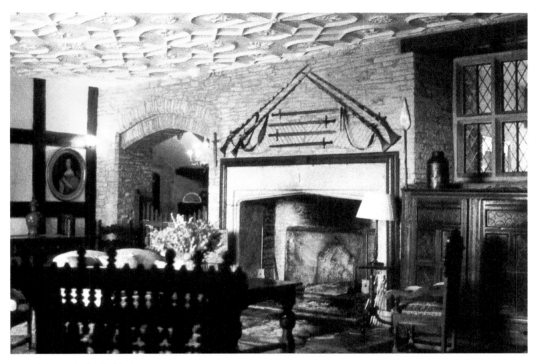

The main hall. (A Copping)

The Morning Room.

house in the grounds, which was sited on the corner of the walls of the walled garden. In the early 1800s the garden was redesigned, the walls, dovecote and another round house removed and a lake and ha-ha put in and interesting trees planted.

The stables are worth a visit. They are among the earliest stabling in Britain, dating from the early to mid-seventeenth century, built by Nicholas Arnold, who was a passionate breeder of horses.

Inside, the main hall has an early picture of the house and estate, some interesting Tudor furniture and spears and a mailed coat used by the Mahdi's troops at the Battle of Omdurman (1898). If Corporal Jones of *Dad's Army* saw the spears, he would have said 'they don't like it up them'.

The dining room has a picture of the owner's grandfather as a child – he fought at the battle. There is also a seventeenth-century charcoal stove, which Simon Jenkins calls 'an early type of Aga'. Up the yew wood staircase, some of the upstairs rooms have good plaster ceilings that Pevsner considers are nineteenth-century copies of Tudor ceiling decoration by Bodley and Garner.

The Round House.

Raglan Castle (CADW)
Raglan, NP15 2BT
(www.cadw.gov.wales/visit/places-to-visit/raglan-castle)

A large ruin today, but not your typical Welsh castle ruin, as Kenyon describes it in the guidebook, Raglan is more of a palace-fortress. To reach it, take the A40 through the tunnel at the end of Monmouth, carry on for about 5 miles, when you see the signpost to the left. It was once a motte and bailey belonging to the Bloet family. Elizabeth Bloet married Sir James Berkeley, who died in 1406. She then married William ap Thomas, Steward to the Duke of York. In 1432, William purchased Raglan manor from the Berkeleys and the castle was begun. Who the architect was, we don't know, but he had Tretower and other examples nearby and it seems money was no problem.

As at Flint Castle, the Great Tower was outside the main castle, 6-foot thick and entered via a drawbridge. This was closed when we visited due to high winds. The son of ap Thomas, William Herbert, was one of the chief supporters of King Edward IV in the Wars of the Roses, during which the great Gate House was completed, as well as the office wing, the kitchens and private accommodation. Alas, Herbert and his brother were executed after the Yorkist defeat at the Battle of Edgecote (near Banbury) in 1469. Work stopped until Raglan came into the hands of Sir Charles Somerset (later 1st Earl of Worcester), who married Earl William Herbert's granddaughter Elizabeth.

Raglan then became more of a house to escape to after the nasty air of London, where the Somersets had their main house. Gardens were built, the

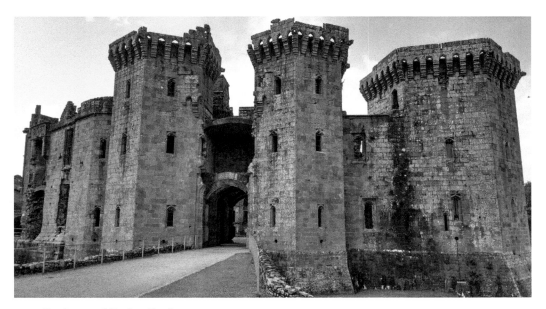

Gatehouse of Raglan Castle.

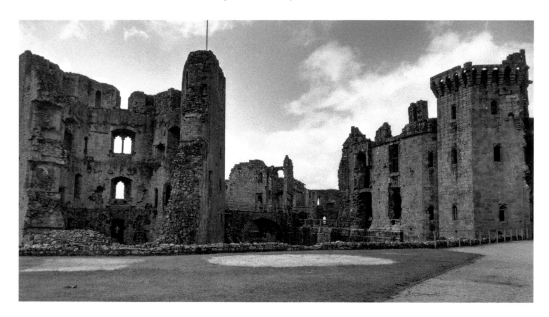

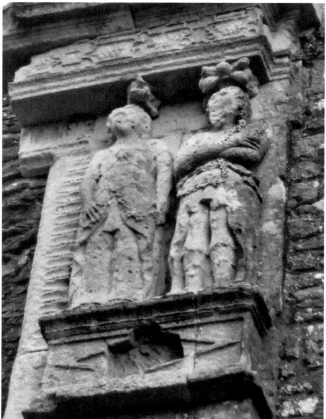

Above: Moated Great Tower of Raglan Castle.

Left: Statues in the upper gallery.

moat built round the great tower, and an upper gallery was constructed. The two statues that can be seen high up to the left of the chapel are part of a chimney piece in this gallery, which must have been accessed by steep stairs close to the wall.

The Somersets entertained King Charles I here after Naseby and Henry Somerset, the aged fifth earl, surrendered to Cromwell's men in August 1646. The castle was slighted as it is today. It soon became a tourist sight, and is well looked after by CADW.

The visitor should go to Raglan church to see the chapel with stained glass depicting the British commander in the Crimea, Lord Raglan. There are three badly mauled alabaster monuments to the Somersets. The Marquis of Worcester, supposedly buried in the church, invented a steam water powered machine, which made a roar like a lion. Some Parliamentary soldiers who arrived to search the Great Tower for arms in 1640, where the marquis had positioned the jets of water from his machine, were frightened off by him turning it on so not only were they soaked but the noise the machine made sounded like escaped lions. Longleat had come to Raglan. The machine was said to have been buried with its inventor in the churchyard.

Tintern Abbey (CADW)
NP16 6SE

(www.cadw.gov.wales/visit/places-to-visit/tintern-abbey)

Crouching beside the River Wye at Tintern are the stately remains of Tintern Abbey. The founder was Richard de Clare in 1131, Anglo-Norman lord of Chepstow. He introduced a small group of Cistercian monks from the Abbey of L'Aumne in France. They followed the rule of St Benedict. Their buildings were of wood at first but by the twelfth century they had a stone church and cloisters. It was not until 1269 that Roger Bigod, Earl of Norfolk, patronised the huge Gothic church that stands there today. Ruined it may be but inside it is huge and there is a new wooden roof on the south side of the nave so there is some shelter. The original church was about a fifth of the size of the new one, which, consecrated in 1301, was in continuous use until Henry VIII's attacks on monasteries in 1536.

Henry Somerset, Earl of Worcester, was granted the building and he leased bits out to people, then demolished other buildings to leave the ruin we see today, which, during the eighteenth century, became a site for the 'picturesque' and a favourite of artists like Turner and the poet Wordsworth, who had relations in Brinsop, Herefordshire. (The church there has a Wordsworth window.) The Ministry of Works carried out preservation work in 1901 when the abbey became Crown property and since 1984 it has been well looked after by CADW, who have sensibly removed loose stones (some are under two tents outside the ticket office, so that one doesn't fall over them as at Abbey Dore).

The railway brought visitors and today there are two car parks, usually full on a nice day, a shop and plenty of picnic space. Much more can be found in David

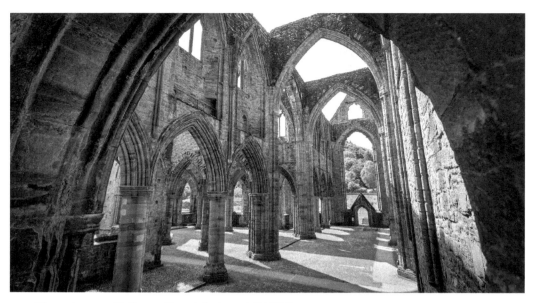

Tintern's nave. (© Crown Copyright (2019) CADW)

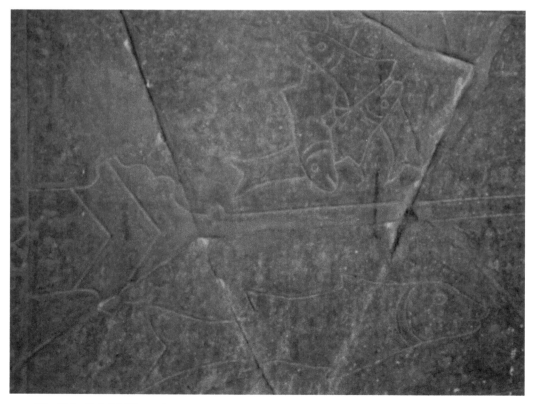

The Fish. (J. S. N. Kinross)

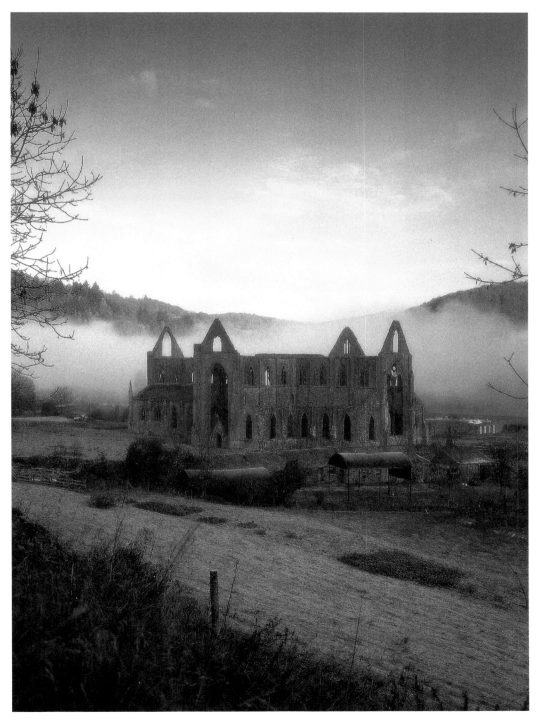

Tintern Abbey. (© Crown Copyright (2019) CADW)

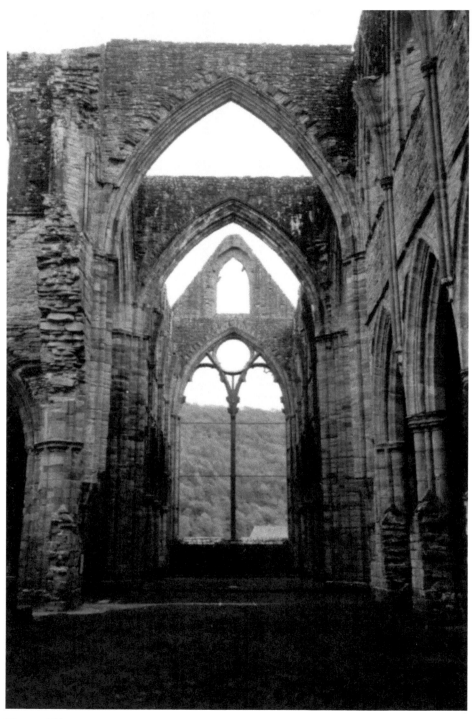

Tintern Abbey. (J. S. N. Kinross)

Robinson's excellent guidebook. Don't forget to see the carvings of the fish – one very large one and several smaller ones on the rectangular stone on the south wall of the abbey nave.

TREOWEN

Treowen Road, Treowen, NP11 3DP
Owners: The Wheelock Brothers
(www.treowen.co.uk)

To find this unusual four-storey house from Monmouth is not easy and a map from the Tourist Office in the Shire Hall is a good start. It is 3 miles from Monmouth down Wonastrow Road (avoid the industrial estate). After 2 miles we came to a 'road closed' sign and had to take a long dogleg to the village of Dingestow where you take the road past the caravans, up a steep hill and the road to Treowen is at the top on the left, down a lane with concrete edges to it, for about 250 yards. The car park is in front of you and the house on the right.

The Davies plan is very useful (RCHMW. Fig 149), although the house is partly restored, with a two-storey porch, but only the back half is now four storeys. It dates from 1627 and it did not originally have a two-storey porch with a coat of arms adopted by the Jones family, which includes the Corbetts, Fitz Walter, Newark, Broadspear, Ynr King of Gwent, Hastings, Wallis and Huntley. Only the latter family (see porch bottom left, chevron and three deer heads) were closely related. Sir Peter Huntley was granted Treowen estate in 1066 for his help with the Norman Conquest. The last of the Huntleys died in the fifteenth century but daughter Margaret had married David ap Jenkins ap Howel – who later took the name of Jones. John Jones inherited Treowen, but it was not until his half-brother Philip Jones, a wealthy grocer, died and left his fortune to William Jones (John's son) that the new house was built *c.* 1627 and the old house nearby was demolished.

The very farm-like house was not to the taste of the Jones ladies and Sir Philip also owned Llarnarth Court (later turned into a psychiatric hospital), which was much more comfortable. The family changed their name from Jones to Herbert and Ivor Herbert, a Major-General in the First World War, became Lord Treowen and rebuilt and restored the house in the 1920s and 1930s. When he died it passed to his nephew, Sir John Herbert, Governor General of Bengal, but he died in 1943 and briefly it passed to a sitting tenant, Mr Davies. They were responsible for the drawings (by the staircase) but in 1954 sold out to the Wheelocks, who own it today. It is used as a self-catering holiday venue and farm, for occasional weddings and is open during summer months.

The main delights are the excellent screen – rescued from Llanarth in 2002 – the massive staircase, rising in short flights of eight steps to the very top of the house, and the unexpected priest hole (the Jones family were Catholics) outside the main great chamber. The latter has a fine but incomplete plaster ceiling (it has been copied, complete, in Drybridge House, Monmouth) and the unexpected corner decorations of flowers, etc., in many of the bedrooms.

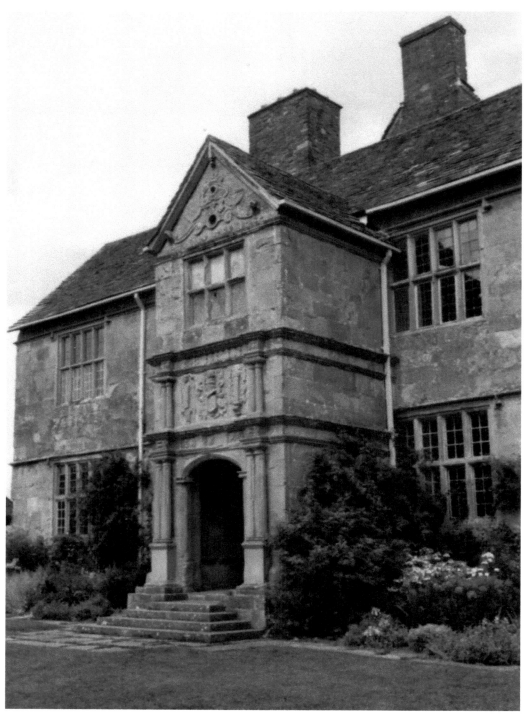

Treowen's porch. Note the coat of arms above the doorway. (J. S. N. Kinross)

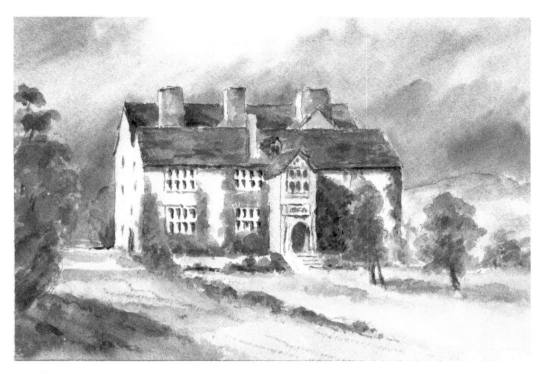

Treowen watercolour, *c*. late 1830s.

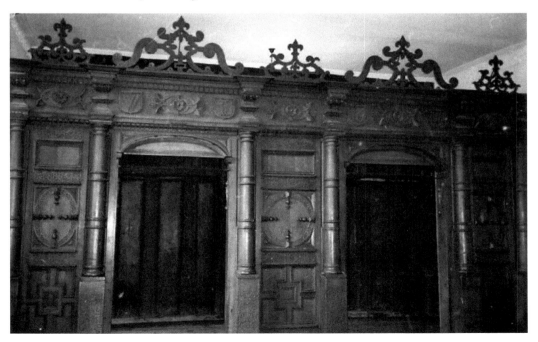

The screen, Treowen. (J. S. N. Kinross)

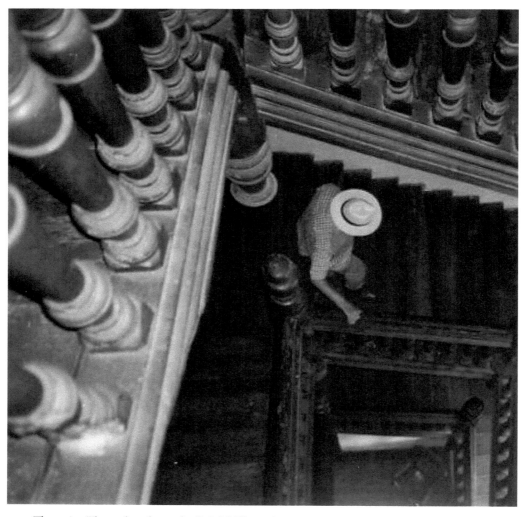

The stairs. The author descends. (J. S. N. Kinross)

MONTGOMERYSHIRE

GREGYNOG HALL (UNIVERSITY OF WALES) (HH)
Newtown, SY16 3PW
(www.gregynog.org)

Gregynog, to those familiar with private presses and books on Welsh history, was started in 1923 by the Misses Gwendoline and Margaret Davies and produced forty-two limited edition books before closing in 1940. It also produced concert programmes and was famous for wood engravings by Blair Hughes-Stanton and the bookbinder George Fisher. The press has been restarted by the University of Wales, the current owners of Gregynog.

Before this, however, it was from the fifteenth century the home of the Blayney family. David Lloyd Blayney was High Sheriff of Montgomeryshire in 1577 and his grandson, John Blayney, followed in his footsteps and the hall was extended in the 1630s. In Tregynon church there is a wooden tablet to the family and a neoclassical relief tomb to Arthur Blayney (d. 1795) by John Bacon RA, which Pevsner describes as 'exquisite'.

The house then passed to Charles Banbury-Tracy, later Lord Sudeley, the 'amateur' architect of Hampton Court in Herefordshire (see *Castles of the Marches*). Lord Sudeley's second son Henry was responsible for the use of concrete strips, painted to look like the original black timber frames. Sudeley sold out to Lord Joicey and, in the 1920s, he sold it to the Davies sisters (their brother, Lord Davies, was one of the original supporters of the League of Nations.

Their grandfather, a coal and railway magnate, left them plenty of money). The house became an arts centre. The sisters collected impressionist paintings (now in Cardiff's National Museum of Wales, which is closed on Mondays). Lord Joicey's billiards room was turned into a music room by the architect E. S. Hall, who worked at Plas Dinam in 1926, building a new wing that has since been demolished. Plas Dinam was originally a Davies family home, built by W. E. Nesfield (1873).

The most attractive room in the house, the Blayney room, has the original wooden panelling of 1636, repaired and added to in the nineteenth century by local man John Llewelyn Jones. It has the coat of arms over the fireplace of John Blayney and his wife Elizabeth.

The gardens were originally laid out in a plan by William Emes, who also worked at Powis Castle, but most of his designs were not realised. The university has employed Sylvia Crowe to draw up a new plan, but on our visit there are so many surrounding trees that there still seems some way to go for her plans to be fulfilled.

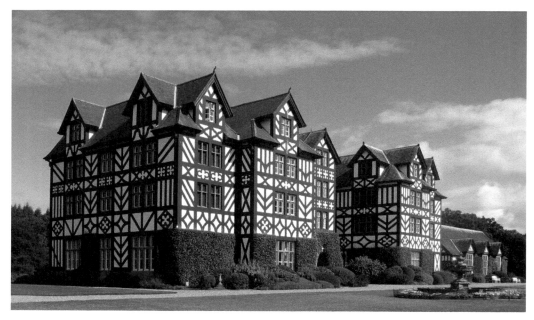

Gregynog Hall.

There are rose beds close to the house, however, and the university appears to be a careful owner, with a librarian who was a mine of information on the two Davies sisters. The gardens are open from May to October (see Yellow Book of NGS).

POWIS CASTLE
Red Lane, Welshpool, SY21 8RE
(www.nationaltrust.org.uk/powis-castle-and-garden)

The massive castle stands high up just outside Welshpool. Unlike Montgomery or other border castles it was not built to keep out the Welsh. When Edward I conquered Wales, the last Prince of Powys (the county has a 'y' not an 'i') Owain ap Gruffyd called himself Baron de la Pole and built the castle, which in 1587 passed to the Herberts – Sir Edward, second son of the 1st Earl of Pembroke. His wife, a Roman Catholic, brought up his family as Catholics, which caused problems in the Civil War.

The castle was captured in October 1644, but doesn't seem to have been much damaged. The Restoration saw it returned to the family and the architect, William Winde, put in improvements like the state bedroom. Lord Powis, like many Catholics, followed King James II into exile in 1688. It wasn't until 1748 that the 3rd Marquis of Powis died and the new owner, a Protestant, Henry Herbert was made Earl of Powis by King George II.

Now came the connections with Clive of India. Robert Clive's son Edward married Lady Henrietta Herbert, the earl's daughter. In 1804 Edward Clive, their son, became the Earl of Powis (3rd creation) and the Clive money went towards

massive repairs to the castle and grounds, with Sir Robert Smirke in charge. At the start of the twentieth century, the 4th Earl appointed G. F. Bodley to make further improvements and Lady Violet, his wife, decided to make the garden the 'most beautiful in England and Wales'. Alas, their two sons died in the First World War and their mother was killed in a car crash (1929), so on his death in 1952 the castle was handed to the National Trust. The present owner, the 8th Earl, welcomes people to his home when he is there. Highlights are the fine pictures, the central staircase, decorated by Lanscroon, the sixteenth-century long gallery with its wonderful ceiling of plasterwork and the Billiard Room, now turned into the Clive museum, which has many Indian objects. However, on a fine day a stroll round the wonderful garden paths and lawns laid down by Violet, wife of the 4th Earl, is a necessity as it surely lives up to her wishes – the finest of all National Trust gardens.

Visitors are advised to read the guidebook first (available in the shop in the churchyard. All pictures are numbered so a list of these is useful – fine if you have a 1996 guidebook.) A pocket torch is useful as the route round the rooms (avoid bank holidays) doesn't always make it easy to read small notices – so too in Erddig.

Don't miss out the museum with the Clive 'swag'. There is a palanquin – minus its bearers and a china one in a glass case. Indian rulers were carried by bearers with poles sliding into slots like a Sedan chair, but usually covered in cloth, so the person being carried could be seen or unseen depending on their wishes. I was disappointed with the tiny gold tiger's head (one of six) but the large original one is in Windsor Castle.

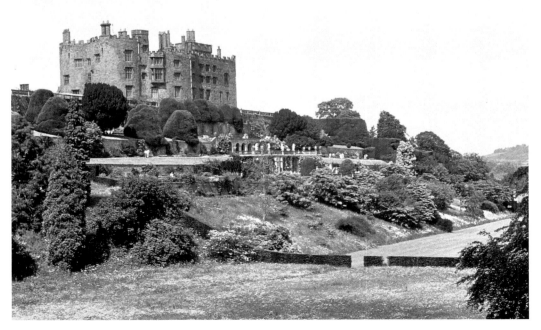

Powis Castle. (Bernard Lowry)

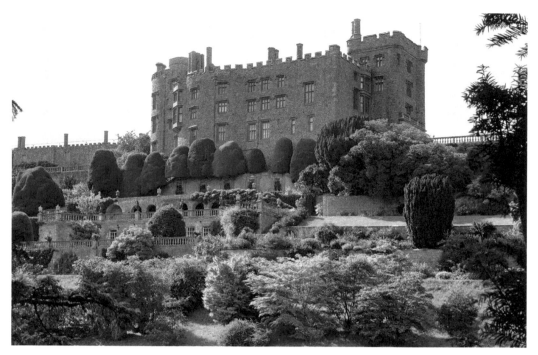

Powis Castle. (Val Corbett)

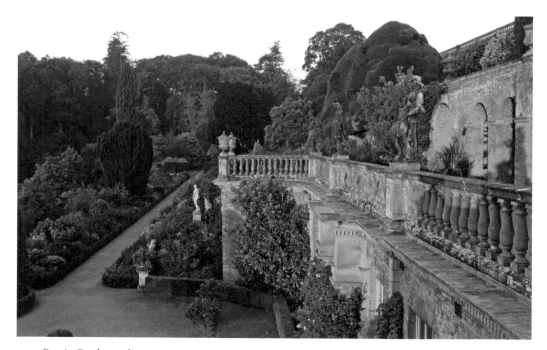

Powis Castle gardens.

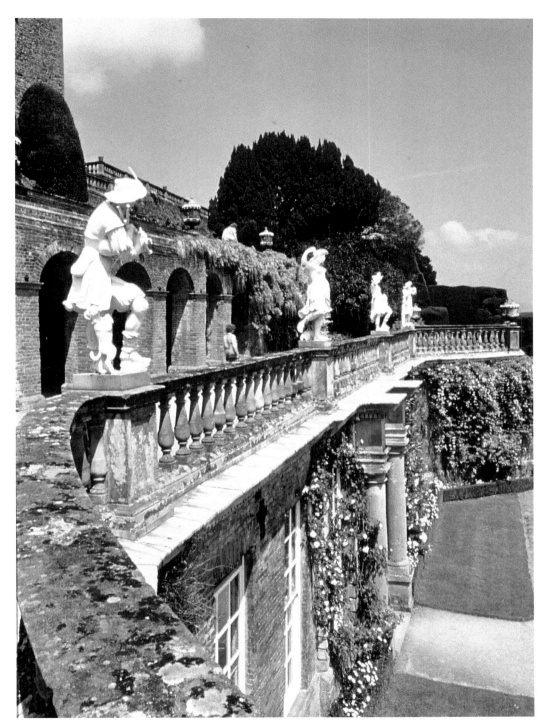

Powis Castle terrace. (Bernard Lowry)

DENBIGHSHIRE

CHIRK

Chirk, Wrexham, LL14 5AF
(www.nationaltrust.org.uk/chirk-castle)

Chirk Castle has already been described in my *Castles of the Marches* but as a private house of the Myddleton family and Lord Howard de Walden, it needs describing as a home. Finished by 1595 when wealthy merchant, later Lord Mayor of London, Sir Thomas Myddleton purchased it and moved in in 1597, it was begun by Roger Mortimer but probably unfinished when Roger was executed as a traitor at Tyburn in 1330.

The Myddleton son fought for Parliament during the Civil War and became a general. His son, however, was a Royalist and had to defend the castle when he took part in Booth's Rising and it was attacked by General Lambert. The east range had to be rebuilt and the east towers seem to have been shortened. The work was carried out when the fourth Sir Thomas and second baronet was a minor. He married Elizabeth, daughter of architect Lady Wilbraham (see Weston Park). Sir Thomas consulted this formidable lady even after the death of Elizabeth.

Architect Joseph Turner was called in in Georgian times and it was he who was responsible for the staircase and the Adam-esque dining room. Mullion windows were put in by Turner. The nineteenth century saw yet more work on the state rooms by A. W. N. Pugin and his partner J. G. Grace. Pugin's son E. W. Pugin carried on after his father's death. However, Lord Howard, who was a tenant from 1911 to 1946, brought in his architects – Ingram and Brown from Scotland – to carry out work, so very little of A. Pugin's original designs are visible. In 1894 the chapel was restored by Blomfield, who took out E. W. Pugin's east window and replaced it with the window there today. Pevsner thinks the clock tower might have been by E. W. Pugin and the entrance door by his father.

The library has been given an interior restoration in 1875 by Richard Myddleton Biddulph. One of the most important books in the collection is the third edition of the Welsh Bible, printed by Robert Barker of London in 1630. The National Trust is fundraising to repair many books in poor condition. Pugin's ribbed ceiling in the library is still extant and there is a fireplace made up of pieces of an old Welsh bedstead.

In the grounds, look out for the thatched roof of what was Joseph Turner's greenhouse and then Pugin's conservatory, which has been made into Lord Howard de Walden's home for his falcons, dated 1912.

The metal gates at the park entrance were made by the Davies brothers in the early eighteenth century, when William Emes was in charge of the garden park

design. The gates were moved in 1888 (so Queen Victoria could admire the beautiful gates from the train) and some side pieces moved to New Hall Lodge, built by Joseph Turner using Doric columns, which was unusual at that time.

The National Trust mentions the Victorian laundry and the servants' hall as worthy of visiting. The Home Farm has a café and gift shop and the car park is 200 yards from the main entrance. It is without shelter in the summer and only guide dogs are allowed in the formal gardens and Pleasure Ground wood. For electric car drivers, there are two power points at Home Farm.

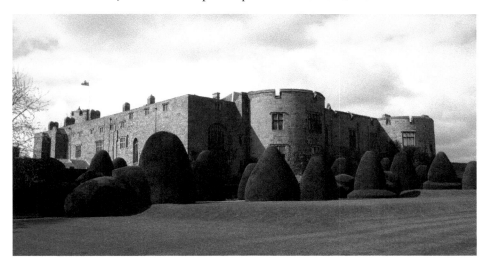

Chirk Castle. (P. Richardson)

The main gates. (Country Life Picture Library)

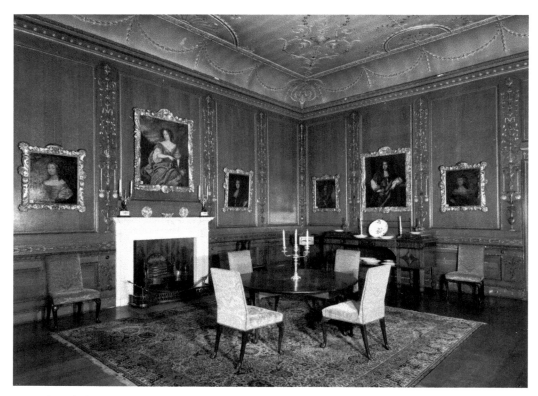

The oak dining room, Chirk. (Country Life Picture Library)

ERDDIG
Wrexham, LL13 0YT
(www.nationaltrust.org.uk/erddig)

Erddig House looks today like a school or military barracks, but when it was built in 1684 a mile south of Wrexham, the east front and formal gardens looked smart and quite suitable for the High Sheriff of Denbighshire, Joshua Edisbury. The tall chimneys of Webb's house, for Thomas Webb, a Chester architect, was hired and set out to build a house 85 feet long by 50 feet deep to a country house plan set out in the Restoration by Sir Roger Pratt. Unfortunately, later owners have added left and right extensions, thus destroying the Pratt design and making the building more like a school or barracks.

The Edisburys did not own it for long as Joshua became bankrupt and moved to London. Fortunately, Sir John Trevor, Master of the Rolls, took out a mortgage on the property and yet did not move there. It wasn't until a barrister, John Mellor, offered £17,000 for the property in 1716 that a new owner moved in. He was a bachelor and his sister acted as his housekeeper. A lot of money was spent on furniture and a Mr Loveday has left an account of a visit there shortly after the new owners had finished the furnishing. He mentions it was 'furnished

in the grandest manner and ye newest fashion; the staircase and rooms are wainscoted with oak ... they are furnished with Mohair, Caffey (cut-wood velvet), damask etc'. The (west) entrance hall has 'new marble chimneypieces, window seats sculpted by Robert Wynne of Ruthin (who was working for the Myddletons of Chirk)'. The chapel was at the far west wing and has never been consecrated. Alas, Meller was never a fit man and he died in 1733. Fortunately his sister Anne had a younger son, Simon Yorke, and it was the Yorkes who were to be the final owners of this large house. At the age of forty-three Simon married nineteen-year-old Dorothy Hutton, heiress to her brother's estate of Newnham, Herts. The Yorkes rented a house in Chester, more to Dorothy's liking as the shops were close by, and only opened Erddig in the summer. Yorke died in 1767 and their son Philip inherited. His wife was Elizabeth Cust, from Belton, Lincs. Her father was Speaker to the House of Commons. Simon Yorke also inherited Newnham, so Erddig at last had some money spent on it, which was much needed. Philip, who inherited the house at the age of twenty-three from his father Simon, was painted by Gainsborough – a great painting in the drawing room shows him with a stick looking out of the window. He was an MP but never spoke at Parliament.

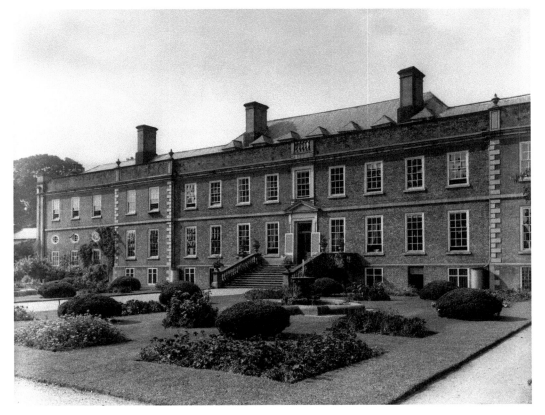

Erddig. (Country Life Picture Library)

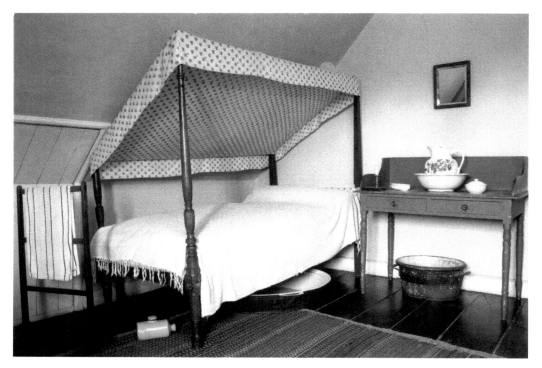

The servant's bedroom, Erddig. Note the stone hot water bottle underneath the bed.

A more active Yorke, Simon York III, who married a Cust cousin, did little to the house in Victorian times. His younger brother John, who became a general, fought at the Charge of the Light Brigade in the Crimea, was wounded in the leg by shrapnel and thereafter kept the splinters in his snuff box. Finally it was Philip York III, who played the musical saw and euphonium (now in the entrance hall) and who was an amateur actor and ran tours to Spain in a Utility bus (picture in the guidebook), who eventually handed over Erddig to the National Trust. The Coal Board had caused subsidence, so they paid compensation of £120,000 and Phillip sold off some land, which raised £1 million so that the trust took over in March 1975. Alas, the trust now struggles to earn enough to keep up the house maintenance in spite of help from many volunteers. However, the unusual house of Erddig is worth a visit in the summer – where else will the visitor find a Tribes Room, a Failures Gallery and two museums. The family museum has a hornet's nest and the garden museum a nineteenth-century potato grading fork. Erddig is indeed a house 'with a human face'.

The gardens are beautifully restored with some pleached limes and a short canal and children's area. There are many fruit trees. Much of the Erddig estate is let out to local farmers.

Appendix I

Landmark Trust Houses

To hire these, contact the trust at Shottesbrooke, Maidenhead, Berks, SL6 3SW, 01628 825925, or www.landmarktrust.org.uk.

The Landmark Trust owns a number of houses in the Marches, which are let out during the year for whoever wants to hire them. They are very well equipped with bedding, kitchens – including stoves and washing-up machines, cutlery, etc. Some can be cold but fires are welcome in fireplaces – including an upstairs woodburner in Llwyn Calyn, which opened in 2018. In Monmouthshire, close to the road to Llanthony Abbey, it sleeps eight in different buildings (Llwyn Calyn was a farm) and would make an excellent centre for hill walkers.

For those who are attending the Hay Festival, there is Maesyronnen Chapel (sleeps four) close to Hay. The cottage is attached to the whitewashed Nonconformist chapel. This is used most Sundays (since 1689) and has wonderful views. For book lovers, Hay is 10 minutes' drive away and supplies can be purchased there. The old range can be fired up in the evening and dogs are welcome.

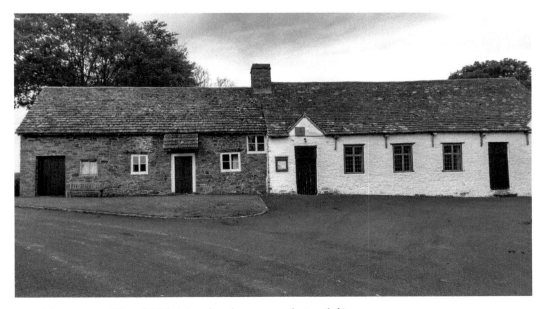

Maesyronnen Chapel (right). Landmark accommodation (left).

Above: Interior of Maesyronnen Chapel,
c. 1910. (National Library of Wales)

Left: Shelwick Court, near Hereford.
(J. S. N. Kinross)

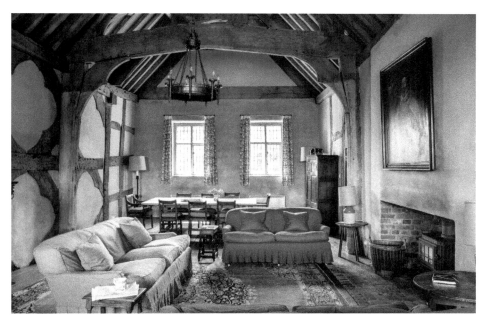

Shelwick Court. (Landmark Trust)

Nearer to Hereford is Shelwick Court, a five-bedroom house close to Pipe and Lyde and on the River Lugg. It sleeps eight and has a medieval great chamber.

Other Landmark Trust properties in the Marches are Bromfield Gatehouse (sleeps six), next to the Ludlow Food Centre, and, just off the A49, Langley Gatehouse (sleeps six), close to the Shropshire village of Ruckley and to Langley Chapel (see *Churches of the Marches)*. The White House (sleeps eight) is on Wenlock Edge and not far from Much Wenlock.

In Monmouthshire and close to Raglan, there is the 1790 folly Clytha Castle (sleeps six).

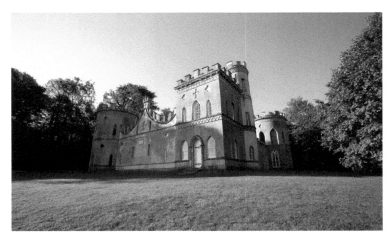

Clytha Castle. (Landmark Trust)

Appendix II

Cwmmau Farmhouse, Brilley (NT)

Signposted down Apostles Lane on the road between Eardisley and Kington, Cwmmau is a black and white farmhouse that used to be in Wales. The western end of Apostles Lane has a T-junction, signed as a no-through road. Ignore this, cross a cattle grid, and half a mile down this road is the farmhouse.

The name 'cwmmau' probably comes from the Welsh word 'cymmer' meaning 'confluence', as two streams meet here. In English, it is known as 'The Cummey'.

The High Sheriff of Herefordshire, Philip Holman, built it in 1620/21 as a hunting lodge where he could entertain his friends. The Holmans, Roman Catholics, were also farmers, as Cwmmau has a cider house, stables and goose pens, three barns, a granary and a cobbled backyard. Holman let it to John Goode from 1630 to 1675 (perhaps Goode was the farmer). Later owners were Perrys and Bromages.

In 1918 it became part of the Curzon Herrick estate and there was a great auction of 3,073 acres including fourteen farms. One Gordon Spearman bought Cwmmau and Fernhall farms, but as a timber merchant he used horses to extract timber and the house was a warehouse for fleeces. Oak panelling and the studded front door were sold to USA and the house suffered.

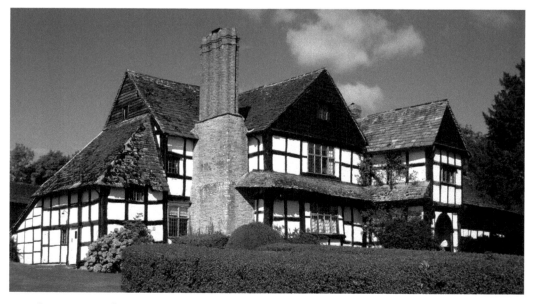

Cwmmau Farmhouse. (National Trust)

Signpost to Cwmmau. Useful for those, like the author, who got lost trying to the find the farmhouse!

Fortunately, in 1934, George Menges, a Lloyds underwriter, became the new owner and with his wife and sister-in-law and restored the house. When he died in 1964 he left it and Fernhall to the National Trust.

One of the bedrooms was turned into a dormitory for ten men who worked on the estate. It has an unusual door in the outside wall of the stairs, 3 feet from the ground, so the men could use this without disturbing the rest of the household. The porch room has a Genesis frieze made by Phyllis Jerrold (the sister-in-law).

The National Trust lets Cwmmau during the year – it sleeps ten, but not all in the same room – and is open for three bank holiday weekends with guided tours.

Appendix III

Historic Houses (www.historichouses.org) have a number of houses in the Marches open three times a year. I have included three that open several times a year here for groups.

Aldenham Park (HH)
Bridgnorth, shropshire

Home of the Acton family, who obtained the estate in 1485, the present Palladian house was built by William Taylor, a London carpenter and architect, in 1691. Inside the young Prince Charles, escaping from Cromwell, hid in a priest hole and left his jacket behind. Later, as King Charles II, he presented the Actons with a Van Dyck picture of his father. There is no connection with Aldenham School, which is miles away in Hertfordshire.

Brithdir Hall (HH)
Berriew, Montgomeryshire, SY21 8AW

A sixteenth-century timber-framed house, Brithdir Hall was reshaped during the Regency period. The owner is ex-Sothebys and the tour includes the flannel and corn mills and much family history.

Brynkinalt Hall (HH)
Nr Chirk, Denbighshire, LL14 5NS

Home of the Trevor family, who still live there, Brynkinalt Hall was built in 1612. Its grounds extend into Chirk so it is very much a place to see, and has a magnificent garden. This is open two days a year in May (see Yellow Book of NGS). The owners say ignore their postcode and the hall is in Trevor Road, near St Mary's Church.

Hardwick Hall (HH)
Ellesmere, Shropshire

Hardwick Hall is an early Georgian house built in 1720 by John Kynaston, whose family still live there. The two-hour guide gives the family history and if you choose a fine day there is a lake one side of the three-storey house and wings and a grand view on the other. Open five days a year. (This house must not be confused with Hardwick Hall, Derbyshire, which is National Trust, or Hardwicke, Gloucs, also HH.)

MILLICHOPE PARK (HH)
Craven Arms, Shropshire

A nineteenth-century Greek revival house by Edward Haycock with an extensive garden. It was built for Revd Pemberton of Church Stretton. It has a large garden with a Rotunda, built by George Steuart, next to a lake. In 1968, Michaela Johnston made improvements for the Lindsay Bury family who own it today.

PLAS DINAM (HH)
Llandinam, Montgomeryshire, SY17 5DQ

Home of the Davies family, this house was designed by W. E. Nesfield in 1873/74 and partly rebuilt after a fire. During the Second World War, Gordonstoun School came here – surely they would have been safer in Scotland. The tour includes a museum and stables.

APPENDIX IV

USEFUL CONTACTS
Historic Houses Association

Historic Houses
Warwick House
25–27 Buckingham Palace Road
London
SW1 0PP

Tel: 0207 259 5688
Email: info@historichouses.org
Website: www.historichouses.org

CADW

Welsh Government
Plas Carew
Unit 5/7 Cefn Coed
Parc Nantgarw
Cardiff
CF15 7QQ

Tel: 0300 025 6000
Email: cadw@gov.wales
Website: www.cadw.gov.wales

English Heritage

English Heritage
The Engine House
Fire Fly Avenue
Swindon
SN2 2EH

Tel: 0370 3331181
Website: www.english-heritage.org.uk
(Customer contact form can be found on website)

Nation Garden Scheme (NTS):

c/o Constable Publishers
Carmelite House
50 Victoria Embankment
London
EC4Y 0DZ

website: www.littlebrown.co.uk

National Trust

Heelis
Kemble Drive
Swindon
SN2 2NA

NT Supporters' Service Centre:

The National Trust
PO Box 574
Manvers
Rotherham
S63 3FH

Tel: 0344 800 1895
Email: enquiries@nationaltrust.org.uk
Website: www.nationaltrust.org.uk

Bibliography

Browne-Kenworthy, J., and Fadden, R., *The Country House Guide* (London, 1979)

Buchan, J., *A Book of Escapes and Hurried Journeys* (Edinburgh: Nelson, 1922)

Cornforth, J., and Hill, O., *English Country House: Caroline* (London, 1966)

Croft, O. G. S., *The House of Croft of Croft Castle* (Hereford, 1949)

Fletcher, H. L. V., *Herefordshire* (London, 1948)

Hudson, *Guide to Heritage in the UK* (Nottingham, 2018)

Hussey, C., *English Country Houses: Early Georgian* (London, 1965)

Hussey, C., *English Country Houses: Mid Georgian* (London, 1963)

Kinross, J., *Castles of the Marches* (Stroud, 2015)

Kinross, J., *Houses with Private Chapels in the Heart of England* (Ross-on-Wye, 2012)

Massingbird, H. M., *Great Houses of England & Wales* (London, 2000)

Mee, A. (ed), *The King's England: Herefordshire*

Mee, A. (ed), *The King's England: Monmouthshire*

Mee, A. (ed), *The King's England: Shropshire*

Mee, A. (ed), *The King's England: Staffordshire*

Pevsner, N., *Clwyd (Denbighshire & Flintshire)*, The Buildings of Wales (London: Hubbard, 1986)

Pevsner, N., *Gloucestershire 2: The Vales and the Forest of Dean,* The Buildings of England (London: Verey & Brooks, 2013)

Pevsner, N., *Gwent/Monmouthshire*, The Buildings of Wales (London: Newman, 2000)

Pevsner, N., *Herefordshire*, The Buildings of England (London: Brooks, 2012)

Pevsner, N., *Powys (Montgomeryshire, Radnorshire & Breconshire)*, The Buildings of Wales (London: Scourfield & Haslam, 2002)

Pevsner, N., *Shropshire,* The Buildings of England (London: Newman, 2006)

Pevsner, N., *Staffordshire*, The Buildings of England (London, 1974)

Robinson, D., *Tintern Abbey* (2011, 5th Edition, revised.)

Robinson, Revd C., *A History of the Mansions and Manors or Herefordshire* (Almeley, 2009)

Rowley, T., *The Welsh Border: Archeology, History.* (Stroud: Landscape, 2001)

Smith, P., *Houses of the Welsh Countryside* (London, 1975)

Timbs, J., and Gunn A., *Abbeys, Castles & Ancient Halls of England and Wales* (London, II Midland, no date but *c.* 1910)

Sundry guides to houses, including the National Trust Handbooks for 2018 and 2021

ACKNOWLEDGEMENTS

This has been a difficult year for all writers and for publishers, so firstly thanks to Amberley for giving me extra time to visit several of these houses that were shut during the pandemic. Thanks to the *Country Life* library for help with pictures and old articles, to Bernard Lowry for help with photographs, and to my son for arranging them. Thanks in particular to Caroline Magnus for correcting my proof of Stokesay Court and to Mrs J. Johnson for showing round and proofreading at Llanvihangel Court; the staff of Berrington Hall; to Gareth Williams, curator of Weston Park; to cousin Miles Cato; my wife for her patience; and to Sallyann for typing and preparing the manuscript for the publishers. All houses included are open to the public, even if by groups rather than singles.

Also by the author:
Castles of the Marches
Battlefields of England and Scotland
Churches of the Marches